PLAYING WITH THE EDGE

PLAYING WITH THE EDGE

THE PHOTOGRAPHIC ACHIEVEMENT
OF ROBERT MAPPLETHORPE

ARTHUR C. DANTO

UNIVERSITY OF CALIFORNIA PRESS

Berkeley Los Angeles London

For Brian Nissin

University of California Press
Berkeley and Los Angeles, California
University of California Press
London, England
Copyright © 1996
by The Regents of the University of California
Printed in Spain
1 2 3 4 5 6 7 8 9

Permissions to reprint may be found on page 196

Library of Congress Cataloging-in-Publication Data
Danto, Arthur Coleman, 1924–
 Playing with the edge : the photographic achievement of
Robert Mapplethorpe / Arthur Danto.
 p. cm.
Includes bibliographical referneces.
ISBN 0-520-20051-9 (cloth : alk. paper)
 1. Mapplethorpe, Robert. I. Title.
TR140.M34D36 1995
770'.92—dc20 94-38950

CONTENTS

ILLUSTRATIONS

ACKNOWLEDGMENTS

My close friend and colleague, Richard Kuhns, read through the original draft of the essay *Playing with the Edge* and made several valuable suggestions for its improvement, all gratefully incorporated. And my wife, Barbara Westman, whose sensibilities I absolutely respect, gave the text the benefit of a delicate reading. I learned a great deal from the narrative structure induced by Mark Holborn onto the two hundred or so images in the Random House publication, *Mapplethorpe,* in which this essay first appeared, and from discussing with him the strategy through which he organized them into a coherent whole: that made my own text that much easier to compose. Dimitri Levas made it possible for me to arrive at some understanding of Robert Mapplethorpe as an artist and as a person; and Lynn Davis helped make my image of him vivid and, I hope, true as far as it attempted to portray him. Tina Sum-

merlin, director of the Mapplethorpe Foundation at the time in which I carried out the research for the essay, was unstinting in help and in encouragement, and gave me access to the often ephemeral publications in which one or another interview with or review of the work of Mapplethorpe appeared. And Michael Stout, who first approached me with the idea that I might write about this controversial and yet engaging artist, was at every stage of my concerns sensitive and sympathetic. Above all I am greatly indebted to Sharon DeLano, a brilliant and intuitive editor, who brought both the essay and the book, *Mapplethorpe,* through. I have unbounded admiration for her sense of style and her critical astuteness.

To the Trustees of the Mapplethorpe Foundation I must express my unqualified appreciation, first for their confidence and then for their forbearance in dealing with the manuscript. They made not the slightest effort to intervene in my discussion and analysis of the artist's work. But I owe to their generosity the fact that the essay now appears here, separate from the magnificent volume of photographic images for which it was first commissioned. It was Edward Dimendberg, of the University of California Press, who felt that a great many in the university world were effectively cut off from responding to the essay by the substantial cost of the Random House volume, and that in a more economical and accessible format it would contribute to the discussion of

those issues with which Mapplethorpe's vision must always be associated. It was he who took the initiative of presenting the proposal to Michael Stout and the Foundation and who took it upon himself to see that the original textual illustrations were made available for this volume. In allowing the project to go forward, the Foundation clearly placed the aesthetic and intellectual discussion of Robert Mapplethorpe's work above any narrow commercial consideration. I can only hope its confidence is in some measure justified as this book enters the classroom, and its arguments carry, perhaps to a new level, the discussion that abated when the mandate of the National Endowment for the Arts was extended for another five years in November 1990. But it would be a great justice if this book were to ignite a wide demand for the Random House volume, with its large array of superbly printed images. In the end, the reader will want to know Mapplethorpe's work itself, and the reproductions in the Random House volume enable one to come within the range of experiencing the original photographs themselves. In the present temper of the times, it may be some while before the core Mapplethorpe images find themselves in any substantial number on the walls of public museums.

I have reprinted my first writing on Mapplethorpe as it appeared in *The Nation* in September 1988, and this gives me an occasion to acknowledge the

constant inspiration I received at that time from Elizabeth Pochoda, who edited the back of the book with an exemplary imagination and an unparalleled smartness. I have had only marvelous relationships with my editors at that magazine, but in the case of Betsy I always brought my pieces in with the hope that they would give her some personal pleasure, beyond whatever critical contribution they might make.

Finally, I must thank my agent, Georges Borchardt, who arranged the crucial practical details for both of this essay's appearances and has always made it a point of principle not to surrender rights.

New York City, 1994

LOOKING AT
ROBERT MAPPLETHORPE'S ART

TWO MOMENTS IN HISTORY

In deciding whether to review an exhibition for my column in *The Nation*, I typically see if there is not some thought or topic, worth developing in its own right, with which I can connect the art, and to the degree that my criticism is at all distinctive, it is because I endeavor to present the art I address in some context wider than the art world alone can offer. The readers of the magazine will in most cases not be able to attend even the shows I do write about, so I have, I feel, an obligation to make the art something worth reading about, and it would be of no great service merely to record my personal reactions, or to interpret and evaluate the works in their own right, as if for an art world audience. Underlying this attitude, I suppose, is the belief that art is connected to the larger concerns of ordinary men and women, whether or not they set foot in museums or galleries, and one purpose of my various columns is to

demonstrate this. Still, a great many exhibitions of note come and go without eliciting a response from me, just because I find no way of fitting the art into some larger moral or philosophical structure that might help my readers—because it initially helped me—both to understand the art and, more important, understand a world that has such art in it.

It says a great deal about the world of 1988, when the Whitney Museum of American Art in New York mounted the first major retrospective exhibition in the United States of the photographic oeuvre of Robert Mapplethorpe, that I saw, initially, no special reason even to attend the show. A year later, that degree of indifference on the part of a responsible art critic would have been unthinkable: in 1989, not long after his death, from AIDS, in March, Mapplethorpe's was the most controversial art in America, raising so many issues of the limits of art, of the obligations of institutions of patronage supported by tax money to the moral codes of the taxpayers, of the relationship of beauty and content, that, just for starters, one could not think about his art without touching on the largest questions of expression, democracy, freedom, censorship, the right to exhibit, the right to see, the right to make art. But in 1988 I was able to feel that there was no urgent reason to think about Mapplethorpe. I passed up the press opening, as well as the formal opening, to which I had been invited, and to which Mapplethorpe himself came in a wheelchair, sur-

rounded by friends and supporters. I was told that he struggled to his feet, insisted on walking through the exhibition, which moved him profoundly, and that he was grateful enough to the Whitney for what it had done for him that he sent it a special photographic acknowledgment of his thanks. It had been common art world knowledge that the artist was dying. But until the opening it was not quite so widely known how close to death he was: he had gone, in a matter of months, from youthful good looks to the appearance of a man old before his time. I finally went, at some point well into the show's run, largely in consequence of a conversation I had at a party attended by some people from the Whitney. One of them, asking whether I was going to review the show, said, when I expressed doubt, that he felt it was important to. He felt that there was a kind of gay sensibility in the work which it would be worth dealing with. That all at once gave me a reason to think about the show. There was, then as now, a great deal of talk about the art of this or that group—of women, or of African-Americans—and the issue seemed important and in fact urgent enough to justify writing about Mapplethorpe's art from the perspective of gayness. As it happened, the work transcended the pretext, and though there can be no question that gay issues are central in the critical assessment of Mapplethorpe's achievement, I am as in the dark as ever about what it means for art to be gay—as much in the dark, in fact, as about

what it means for art to be feminine or masculine, or subject, for that matter, to any of the predicates of political correctness.

For reasons that parallel the possibility of wondering, in 1988, whether there was enough by way of larger issues to justify thinking about Mapplethorpe, it is almost impossible to imagine, today, what it was like in 1988, before his art had become notorious, to visit an exhibition of his work. Once his name burst into mass consciousness, after the cancellation of a show of his photographs that bore the coy title "The Perfect Moment" at the Corcoran in Washington, allegedly because of its fierce sexual content and the opportunity this might give the Congress to balk at renewing the mandate of the National Endowment for the Arts, a certain almost choreographed scenario affected and afflicted all the subsequent venues of that show, in Washington, in Berkeley, in Cincinnati, in Boston, and elsewhere. I am not referring merely to the upheavals registered in talk shows, the evening news, the op ed pages, the demonstrations and pulpit denunciations, the placards and leaflets, the threats and tumults, through which America deals with any cause that may threaten to disturb some boundary line of morality. I am referring to the ordeal everyone who visited the show had to undergo: the long waits, the taunts of demonstrators and counterdemonstrators, the crowded galleries, the constabulary presence, the way the images from the notorious X portfolio

4

were segregated off in specially marked precincts into which one could not possibly wander by accident, so that one had to make a moral decision whether or not to look at them—and then the yammerings of high-minded docents, leading tour groups, proclaiming that aesthetic merit trumps moral content and that artists must be free, free, free. Against what had become the standard agony of putting oneself in the presence of Mapplethorpe's art in 1989, the experience of seeing it at the Whitney, in 1988, before anyone much knew about the artist, has, in retrospect, the uncanniness of a dream in which one visits an exhibition of Mapplethorpe's art. There was the silence and the emptiness that, thanks perhaps to the surrealists, we now associate with the landscape of the dream. On the muggy August afternoon of my visit, the galleries were sparsely populated by people who conversed in hushed tones or stood silently, for as long as they cared to, before some arresting image. I have often enough thought, afterward, that no one, ever again, will be able to experience Mapplethorpe's art in that profound private way. The images have become celebrities, and have, in consequence of that station, forfeited the right to privacy.

I have thought no less often of the brilliant syntax of the Whitney exhibition, which was the creation of Richard Marshall, then a curator of the museum. To the right of the entryway into the exhibition were three photo-

5

graphs—a portrait of Louise Nevelson, recently deceased; a seated male nude, shown from the rear, named Carleton; and, more difficult to read at first, the image of a man's nipple, surrounded by fine hairs. On the other side of the entryway, and at right angles to these—as well as much larger—was a self-portrait of the artist, wearing formal clothing, still handsome but with that aged, wasted look that took possession of his features as he neared death. That would be the last image one would see upon leaving the show, but situated where it was, to one side of the passageway in and out of the exhibition but connected syntactically with the three pictures on the other side, which served as overture to the show, it was as if the artist were contemplating in those images what had given meaning to his life. The look on the artist's face was quizzical and, in an old-fashioned sense of the term, philosophical, pondering that meaning, struggling to bring his life into perspective. The face of Nevelson symbolized art, the portrait, and death. The nude symbolized beauty and grace and the quest for perfection. The nipple was an emblem of the erotic, of the body as the scene of pleasure, humiliation, and pain. (There is an early documentary, narrated by Patti Smith, of Robert Mapplethorpe having his nipple pierced.) The tremendous concept at the entryway was of the artist, looking across that gap at his images and backward over his life, thinking: that is what I lived for, and that is what my own death means as well. Read

in this way, one could have seen that this was not simply an exhibition of art. It was the symbolic enactment of an artist's life.

The first galleries, as I recall them, contained some early work interspersed with portraits, nudes, flower studies, and some rather strange sexualized images, not always easy to read or, when easy to read, not always easy to believe. There was, for example, a picture of male genitals trussed up in some way so at odds with anything I had ever seen or even imagined done to male genitals that I was unable to acknowledge it as a picture of something an actual person had allowed to happen to his cock and balls, some painful wished-for masochistic infliction that had never entered my own repertoire of fantasies: I thought it had to be a photograph of some sort of sculpture. The photographer Lynn Davis told me that she and Mapplethorpe, early in their friendship, achieved a kind of sibling intimacy, and that they talked by phone every day. This started when Robert was very active in sadomasochist sex, and every day he would phone and describe to her what he had done the night before. She said in effect that at times her jaw would hang open in amazement, and once she asked him whether some particular act was something he had thought about doing all his life. No, he said, he had never even heard of it until last night, when he did it. That remark made a considerable impression on me. It is the mark of fantasies that we return, obsessively and

repetitively, to the same images and the same scenarios, over and over again. We do not for the most part live our fantasies out, and so they never evolve. But the form of life Mapplethorpe had entered had made of sex a public practice, and this enabled it to evolve in ways quite beyond the power of private fantasy to anticipate. Whatever one might think of it, sex was probably lived more creatively in those years when the barriers to its enactment had fallen than at any other time in history. It had become as public as a language. Wittgenstein wrote that to imagine a language is to imagine a form of life. But then the language is unclear to those alien to the form of life, as I was to the life recorded or even celebrated in some of the images in the show. I remember passing the triptych *Jim and Tom, Sausalito*, in which it looked as if a masked man were peeing into the open mouth of a kneeling man. It looked that way but I was uncertain that was what the pictures showed. Again, nothing in my experience or my fantasy had prepared me for an image of that sort of act, let alone a photograph that showed anything like it taking place.

All these unclarities dissolved upon entering the furthermost gallery from the entrance, about halfway through the show. Here were the images destined to become famous, or in any case notorious, for even when the Mapplethorpe controversy raged the following year, a very small proportion of those who knew about them had seen them or even seen reproductions of them. A pub-

lication of the College Art Association, in the spirit of visual knowledge that one would suppose defined the purposes of that organization, went so far as to remedy this discrepancy by actually publishing the images. This caused nearly as great a controversy among members of that association as within the population at large. I had the immense benefit of coming upon them unprepared, not even knowing of their existence beforehand. It was, for me, a thrilling experience, for the freshness of artistic vision transcended without obliterating the extremity of the images of the leather-clad man displaying his immense penis on a kind of altar; of the artist himself, again clad in leather, displaying a lethal bullwhip protruding from his bared ass; of the master-and-slave in their neat bourgeois living room, wearing the regalia of domination. It was transparent to me that Mapplethorpe's contribution was in this genre of photography, however it was to be interpreted and understood. But at a visceral level it was an exceedingly frightening moment: those were real people who had put themselves in that way in front of the camera, individuals for whom a certain kind of sexuality was their attribute in the same way as a certain kind of suffering, embodied in some instrument of torment and degradation, was the attribute of the martyr. They clearly trusted the artist, who recorded the extremity of their sexual being with an uninflected clarity and candor, and who, given the physical constraints of the photographic session,

had to have shared a space with them as well as a set of values, since he showed himself as participant in the same form of life. That left the question of the viewer, with the images to deal with, facing the rest of the show, but more than that: facing the moral questions of art from an altogether new perspective, rather more complex than those having merely to do with content, and facing the reality of sex from a perspective one might have thought about as a distant pathology but had never confronted as a lived reality before.

I have thought a great deal of that small gallery, at the furthermost corner of the floor given over to Mapplethorpe's work. For one thing, one came upon it, without warning. All at once, after the flowers and the portraits, the sculptural frames, the clouded sexual imagery, the marvelous posed nude bodies, black or white, one was in the presence of a set of images that drove one away and drew one to them in some kind of oscillation of will. One wanted to escape and one wanted a further contemplation. But the exhibition was so structured that one could not escape the experience: it was upon one before one knew it, and one had to deal with it as best one could. It was pretty much a case of what Heidegger called *Geworfenheit*, or "thrownness." Beings such as ourselves are "thrown" into the world and must come to terms, philosophically, with this original condition. One had in the same way to rise to some level of reflection on the art one had just been thrown into the presence of. The

first half of the show was now far clearer than when one experienced it, and far scarier. The uncompleted half remained to be gone through, and one had no idea what visual dangers lay ahead.

Since the Whitney show I have reflected in a general way on the syntax of exhibitions, and I return to Richard Marshall's marvelous achievement with ever-increasing admiration. For example, it struck me, when I was discussing with Mark Holborn, the great photography editor, the book of Mapplethorpe's photographs for which I was to write an essay, that there was a great difference between an exhibition and a book. The exhibition moves us physically from space to space, and though we have a certain freedom as to how we move about in any given space—one does not simply move from work to work, serially, around the room, unless actually constrained to by guide ropes—one has no choice when it comes to going into the next gallery, unless one is explicitly given that choice, as in the Mapplethorpe shows where the dangerous images are sequestered and the public is warned about them in such a way that entering the gallery is an act of informed consent—like undergoing surgery. How would one contrive matters in a book so that the reader would *come upon* a set of images that would throw the entire corpus in perspective the way it happened in Marshall's installation? For, especially with a book of images, we can enter it at any point, opening the book at will.

11

It was Holborn's decision to segregate the dark images from the rest, set apart by red inserts. Somehow that, for me, destroys the organic connection between them and the rest of the work, as if the images of violent sexualists were capsulated in the whole and could be absent or present without affecting the rest. In some way those images are present in everything Mapplethorpe did, however little sexualized this or that image may seem to be. And Marshall's installation created a knowledge of the organic unity of Mapplethorpe's work by putting the visitor to it in a frightening situation, namely, that of the corner gallery, with one door leading back in the direction one came from and another in the direction of the unknown.

The difference between art and image when the two have the same content was dramatically clarified for me some time later, when I was doing the research for the essay that follows. I was talking with Dimitri Levas, who was, in a way, Mapplethorpe's "producer," arranging the details of the studio, choosing the flowers, dealing with models, suggesting ideas of all sorts. We were in the offices of the Mapplethorpe Foundation. Dimitri brought in a carton on which SEX was written in ballpoint pen. "I think you ought to see these," he said, leaving me alone. The box had shots of men engaged in sadomasochistic practices, doing to one another things evidently deeply wanted, perhaps deeply wanted by many of us who keep the cravings sufficiently re-

12

pressed as to be unaware of possessing them to begin with. They were work-
ing shots. Mapplethorpe was there, recording the session, which happened to
be a sex session but which could have been men engaged in any group activity,
so far as the urgency and artlessness of the photographs went. It was very raw,
and altogether unmediated by art. Dimitri told me that the phone would ring,
inviting the artist, known to be interested, to come and take pictures of a ses-
sion of sex. Some of the images from the Whitney show came from some of
the engagements in the SEX box, so I was able to see what they meant in a
wider context. It was, in any case, an extremely painful experience to go
through the photographs, and I was unable, finally, to look at everything the
box contained. I gave up halfway through, and when I got home that evening
my wife wanted to know what had happened to me. I looked pale and shaken,
and it took a while before the images faded. They were powerful and cruel,
and though on the scale of suffering one witnesses every evening on cable
news, the actual pain depicted was slight and of the imagination, the fact that
it was voluntary and strange, that it was an exercise of spirit, gave it an edge
of meaning that had to be dealt with in a different way from the meaningless,
pointless, unwanted suffering of Rwanda or Bosnia. In any case I was not pale
and shaken when I left the Whitney show. I was profoundly stirred and put
into a reflective mood, grateful beyond measure to have gone through an

13

exhibition I might have missed. I was *exalted*. The photographs in the box were not yet art. They belonged to photodocumentation. The photographs of the show had become art by transcending their documentary origins in ways I later sought to analyze in the essay printed here.

I published my review of the Mapplethorpe exhibit in the September 26, 1988, issue of *The Nation*. It was a virtue of the piece that I dealt at length and in detail with the sexual imagery, and even somewhat comically with the huge penises shown elongated atop pedestals or hanging out of open flys or merely swinging like bats between model's legs—or metamorphosed as eggplants, bunches of grapes, or fish. It became pretty clear to me that one of the reasons I had been initially indifferent to the idea of Mapplethorpe was that there had been a pale of silence in regard to the sexuality of the work: none of the show's energy or excitement was described in the critical press. It was as if critics were reviewing a show of Weston! I felt I owed it to the public to explain what drove Mapplethorpe's art, and what one was going to have to deal with in undertaking to encounter the work for oneself. I felt rewarded when I learned, through Richard Marshall, that Mapplethorpe had read and admired my review. He was not any kind of reader—his boasting to Janet Kardon in an interview that he did read the *New York Post* is already a confession of aliteracy. But it was I think Dimitri who showed him my review,

perhaps saying, "I think you should see this"—which explains his having looked at it. He was, Marshall told me, amazed that a philosopher should have written about him as I had done. I afterward thought that the comic tone with which I talked about some of the images might have pleased him, since he thought of his work, at times at least, as funny. In any case, I tried to deal with the sex as well as someone could who did not share an environment with the artist. I never met or laid eyes on Robert Mapplethorpe. Our only communication was the review for *The Nation*, and his indirect acknowledgment of it. I suppose it would have been nice to meet. But I often review the work of artists whom I never meet, or merely meet. It is rare that anything comes of those encounters.

Robert Mapplethorpe died on March 9, 1989, attended chiefly by women friends, at the New England Deaconess Hospital in Boston. He was forty-three years of age, and it is a fascinating and unanswerable counterfactual question what he would have achieved as an artist had he lived a longer life. The exhibition "The Perfect Moment," supported to the extent of a $10,000.00 grant from the National Endowment for the Arts, opened the previous December at the Institute of Contemporary Art in Philadelphia, which the artist was too ill to attend. Two weeks before its projected venue at the Corcoran Gallery in Washington, D.C., the show was canceled by

the director, Christina Orr-Cahall, hoping to avoid controversy and pre-cipitating, by that very action, a vast controversy, for which Mapplethorpe's work was the occasion, over the larger questions of public funding of the arts as against considerations of artistic freedom. There is a fascinating and possibly answerable counterfactual question of what form the controversy would have taken had this decision by Orr-Cahall not been made. Given the journalistic silence that muffled the Whitney show, given the frequency with which members of Congress visit art museums, my own sense is that the issue would never have risen in the virulent form it assumed. But Orr-Cahall, in her letter of resignation in December 1989, wrote that "the Corcoran was, according to counsel, likely to become a target and test case for the law, and to establish the legal relationship between art and por-nography, particularly child pornography." She reports that by June 8—the decision to cancel was made four days later—"over 100 members of Con-gress had heard from their constituents concerning the use of taxpayers' monies in the funding of the Mapplethorpe exhibition." In candor, that does not strike me as an avalanche of protest. Orr-Cahall believed it was in the best interests of artistic freedom and of the Corcoran as an institution that the latter "not be caught in the middle of a debate which it could not control."[1] She was wrong on both counts.

Whatever the case, the aesthetic news brought by my *Nation* review must, read in the backward light of the controversies of 1989 and 1990, make it appear as if the writer came from another planet. The pornographic content was a matter of universal knowledge shortly after the artist's death. What the artistic significance of its being pornographic was remained unanswered, however, given the urgency of the issues as felt by anyone in the art world of those years. I wrote two pieces dealing with aesthetic politics, one an editorial for *The Nation*, in August 1989, called "Art and the Taxpayers," which sought to respond to an article by Hilton Kramer, which appeared in the *New York Times* on July 2, under the headline "Is Art above the Laws of Decency?" And in a number of lectures I sought to analyze the connection between freedom and responsibility to the taxpayers' assumed moral standards. The final version was presented at a scheduled meeting of the American Academy of Arts and Sciences in Los Angeles and published in my book *Beyond the Brillo Box: Art in the Post-Historical Period* in 1992.

The relationship between art and what Mr. Kramer termed "decency" remains intricate. There were some who made decency of content a condition for art, excluding the photographs from the X portfolio from the domain of the National Endowment for the Arts by definition. It is to Mr. Kramer's credit that, however inclined he may have been to take this line, he resisted.

17

"Are these disputed pictures works of art? My own answer to this question, as far as the Mapplethorpe pictures are concerned, is: Alas, I suppose they are." This is not to say, Kramer adds, that "the Mapplethorpe pictures belong to the highest levels of art—in my opinion, they do not—but I know of no way to exclude them from the realm of art itself."[2] By the formalist standards of critical appraisal that prevailed in museum and art-historical circles until the most recent times, Mapplethorpe's work ought by rights to qualify as art "of the highest level." But those standards had badly eroded by the 1990s, all at once exposing Mapplethorpe to criticism from an unanticipated direction. In Joseph Kossuth's installation "The Play of the Unmentionable," which selected objects from the collection of the Brooklyn Museum which were, for whatever reason, "unmentionable"—because of nudity, because of eroticism—the artist included photographs from Larry Clark's portfolio "Teen Age Lust." In the essay by art historian David Freedberg for the exhibition's catalog, Mapplethorpe's pictures are unfavorably compared to Clark's staged, lubricious images: "Beside them, photographs by Mapplethorpe . . . must have seemed altogether innocuous and tame, slick and decorative." And, later in the essay, he repeats: "Beside him [i.e., Clark], Mapplethorpe's works look a little too smooth, stylish, and marketable." The term "marketable" is an index to the transformation in attitude from formalism to

a certain "smooth, stylish, and [academically] marketable" Marxism, which had come to replace it.[3] The question, raised from right and from left, was how good an artist Mapplethorpe was, and the way in which the pornographic content of his art affected its standing one way or another. Freedberg's implied critical suggestion is that that kind of content should be reflected in the form—unpolished, free, "uninstitutionalized," as in the work of Clark. And at the very least the possibility of taking such a position is evidence that, in one or another way, strong sexual content now having been accepted, the question was how criticism should deal with it.

The opportunity to consider these questions at leisure and at length came with the invitation to write the present essay.

The Mapplethorpe Foundation had signed an agreement to publish, with Random House, five books of Mapplethorpe's work. The aim, of course, was financial: the foundation has a variety of causes it supports, among them the treatment of AIDS, and it is the responsibility of its trustees to seek ways of increasing its endowment. The decision had been made to publish a "definitive" volume, with around 250 photographs beautifully reproduced, as its inaugural venture, and the question arose of who should write the essay. Ingrid Sischy, who had written about the artist with great sympathy and was indeed one of his friends, was first approached, but she felt she had said what she

wanted to say about the art of Robert Mapplethorpe, and recommended that they ask me. I felt that the reception of my earlier review by Mapplethorpe may have been a disposing factor. It was certainly a disposing factor for me. It is rare enough when an art critic has attained the artist's acceptance of what had been written. But I had the further sense that the artist's death somehow imposed a certain obligation.

Still, it was a very different world in which Michael Stout, the president of the foundation, asked me to undertake this task from the one in which I wrote about a largely underknown artist for a presumably liberal readership. And in truth I was not eager to expose myself to attacks from self-appointed defenders of decency and uprightness. I told Michael Stout, moreover, that I was in no sense an insider to Mapplethorpe's world, which held no special appeal for me erotically or emotionally. So there was a bit of a worry that there might be some failure of empathy: I confess to being a great deal more excited by Larry Clark's pictures, partly because of their heterosexual content, partly because I imagine the sexual fantasies of most of us are teenage formations that never especially change. In the end, however, such hesitations could count for very little in the face of so challenging an assignment. Here was the opportunity to write about the things that interested me most in the world—about art, about the conceptual structures of photographic represen-

20

tation, about sexuality, about the power of images, about beauty and morality, and about an artist who embodied the seventies in America, which was certainly socially and, in a view I am becoming increasingly convinced of, artistically the most important decade of the century. It was the seventies in which the objective pluralistic structure of the art world first began to show itself as something distinctive. It was the seventies in which indeterminately many directions began to show themselves as available to artists without any historical possibility of showing themselves as *the* historical direction for art. And beyond these speculative matters there was the chance to write critically and expansively on Mapplethorpe as an artist. What finally convinced me to accept the commission was the chagrin I am certain I would have felt had someone else been offered it after I had turned it down, and I then read the result, thinking I could do better. I put myself entirely into this essay, as philosopher, as critic, and as person. I felt, at the end, that I had achieved a certain understanding of some of the driving issues, not just of our time, but of the human condition itself.

PLAYING WITH THE EDGE

THE PHOTOGRAPHIC ACHIEVEMENT
OF ROBERT MAPPLETHORPE

There is a tension at the heart of Robert Mapplethorpe's art, verging on paradox, between its most distinctive content and its mode of presentation. The content of the work is often sufficiently erotic to be considered pornographic, even by the artist, while the aesthetic of its presentation is chastely classic—it is Dionysiac *and* Apollonian at once. The content cannot have been a serious possibility for a major artist at any previous moment in history. It is peculiar to America in the 1970s, a decade Mapplethorpe exemplifies in terms of his values, his sensibilities, and his attitudes. But content apart, the photographs seem scarcely to belong to his own time at all. They are controlled, composed exercises in a classical mode. They fit, aesthetically, with the photographs of the nineteenth century, which Mapplethorpe admired and collected, far more than they do with the work of his contemporaries. Dionysus was the god of

frenzy, Apollo the god of proportion and of form. According to Nietzsche, the two opposed deities together generated tragedy, and perhaps the dissonance between content and form in Mapplethorpe's work conveys the dark excitement of tragedy as well.

As a person, Mapplethorpe lived along both dimensions of his art. He frequented the wilder precincts of sexual expression that the general lifting of prohibitions opened up for exploration in the late 1960s, but he aspired to a code of conduct hardly typical of the times, somewhere between dandyism and gentlemanliness. The embodiment in Mapplethorpe's work of these polarities—uninhibited and austere, dirty and pure, wild and disciplined—perhaps explains the undeniable power of his greatest images. It also explains why the work was and remains the focus of hostile criticism. However liberated the sexual mores of the age, they were hardly loose enough to accommodate as acceptable the sadomasochistic practices he celebrated. But neither did the formal beauty to which his art aspired recommend him to the artistic establishment. However modern its content, its severe classicism seemed to consign it to another age.

It is interesting to contrast Mapplethorpe's art with that of another artist of the period, one who found favor, even great favor, with the arbiters of photographic taste, namely Garry Winogrand. Toward the end of his life, in an

interview with Janet Kardon, Mapplethorpe observed that his pictures were "the opposite of Garry Winogrand's." This is nowhere more apparent than in the albums each produced of photographs of women. *Women Are Beautiful* was published by Winogrand in 1975. *Some Women*, by Mapplethorpe, was published posthumously in 1989, but was put together in consultation with his friend and colleague Dimitri Levas before his death. The difference between the visions of these two artists, made palpable in the two collections, lays bare a number of the basic variables of photography as an art.

Women Are Beautiful shows anonymous women bent on private errands, crossing streets or striding along sidewalks, singly or in pairs, alone or as part of an urban crowd. It is an exceedingly personal book, even if, or perhaps because, the subjects are all perfect strangers to the artist, for it is dense with longing and what the viewer senses is a kind of sexual desperation. It may someday serve as a document of how women dressed in the sixties, how they wore their hair and made up their faces, but it also documents the role they play for Winogrand as a photographer, his yearning for them. None of the subjects consented to being photographed. The camera caught them in midtrajectory, and their expressions are uncomposed and natural, as the photographs themselves seem uncomposed and natural. Winogrand famously remarked that he photographed in order to see what the things that interested

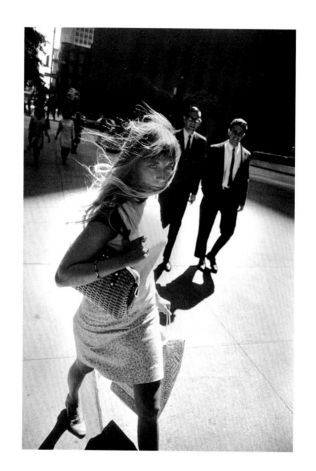

Garry Winogrand, *New York*, 1965

him looked like as photographs. So in one sense he was invading his subjects' lives, if only momentarily, in the spirit of conducting an artistic experiment that more often failed than succeeded. "Winogrand was uninterested in making pictures that he knew would succeed," John Szarkowski wrote in evident admiration. "One might guess that in the last twenty years of his life, excepting his commercial work, he never made an exposure that he was confident would satisfy him."[1]

"In general, women disliked the book," Szarkowski added, and it is not difficult to see why. Winogrand was as much interested in the tactics of getting the pictures as he was in the pictures he got. He may have been more interested in that. And for his own ends he violated a certain code of civility—the right to privacy. The women are fully clothed, but they are seen as female flesh. "He finally admitted," Szarkowski observed, "that women impaired his critical faculties. He was an easy mark for the rhetoric of women's bodies."[2] At the same time, the images are extremely aggressive toward the women for whom the artist hungers. The pictures are tilted, for example, in such a way that it is impossible to suppress the thought that the camera offered Winogrand a way of looking down bosoms. The women, taken unawares, have unprotected breasts: they have not had time to cross their arms. Occasionally a woman sees the camera aimed at her, but too late to do more than

28

Man Ray, *Retour à la Raison*, 1923

gaze balefully into the lens. In *New York*, a woman with a shopping bag and straw wicker purse, her hair blown back across her face, fails to see that her salient breast is being visually nipped by the scissors-like legs of a man in a dark suit who, with his colleague, grins appreciatively at the camera. Fully clothed or not, the women in Winogrand's photographs are victims of an obscene attention.

The women in Mapplethorpe's *Some Women*, by contrast, are not anonymous. Even when all we are shown is a nude torso, cropped, like that of Lydia Cheng, at the knee and neck, so that the body looks altogether impersonal, it is given an identity and an owner: it is the body of a particular woman who consented to be shown nude. In one sense, I suppose, Lydia Cheng is treated as an object: the photographer has posed her as he might place a statue. And he clothed her in slanting shadows. There is a possible art-historical reference to Man Ray's photographs of Lee Miller, but there is far greater dignity and even a chastity in Mapplethorpe's photograph that Man Ray could not allow himself, given his need to turn the female body into something surreal.

Unclothed, Lydia Cheng's perfect body is immeasurably less suggestive than Winogrand's passing beauties in skirts or slacks. The same is true of Lisa Marie, whose breasts are shown from below in a study from 1987. We see the

29

30

Lydia Cheng, 1987

breasts, as we saw Lydia Cheng's torso, against an abstract black background, caressed by a soft light that reflects off fine hairs under the nipples and reveals the texture of skin stretched taut. Skin and hair notwithstanding, the overall impression is of marble forms, and seen as they are from underneath, Lisa Marie's breasts appear to resolve into an abstract sculpture of biomorphic shapes, akin to something by Hans Arp, or, in one of her moods, Louise Bourgeois. But this awkward perspective was consented to, and addressed by the artist with the subject's full knowledge and cooperation. Lisa Marie is being treated as an end and not as a means, and there is not the slightest sense of obscenity, let alone pornography.

As if in formal acknowledgment of the agreement between subject and artist, the images in *Some Women* are extremely well composed. The photographic sessions were collaborations undertaken for the sake of an image, and though failures were always possible as well as accidents of success, and though the result may not have been what either the artist or the subject had expected, failure was not the risk Mapplethorpe took in hope of luck being on his side. Dimitri Levas told me that all the shots in the contact sheets looked pretty much like the one selected for the final image, as if the photographer knew precisely what the outcome would be. He did not count on the fortuitous fall of a garment, an unanticipated ripple of muscle.

31

32

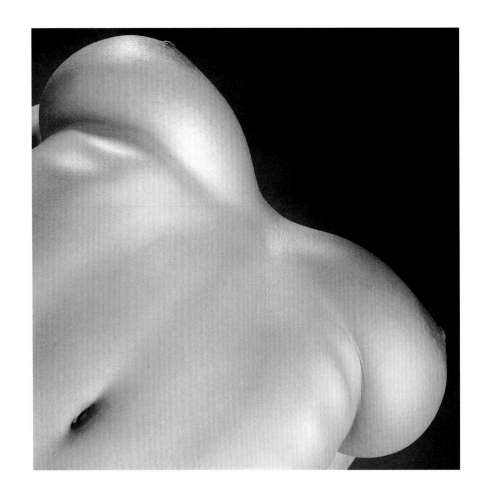

Breasts, 1987

The trust that was a morally and artistically indispensable component of these sessions is palpable in the images in *Some Women* that explicitly provoke. Lara Harris, for instance, bares one breast, underscoring its visibility with her lowered arm. And she stares out at the viewer, as if to say, "Is this what you want to see? Here, have a look. It's just a woman's breast!" Annamirl, in an image of 1984, lightly palpates her breast, with a look so cool and self-possessed that one feels she is reminding the viewer that the breast is a source of nourishment and warmth and comfort as much as or more than a target of arousal and stimulation. Perhaps the most clearly eroticized image in the book is of a woman's foot in a spike-heeled, patent-leather shoe, the footgear, one knows without being told, of a dominatrix: even the ankle straps connote bondage. It is a fetishistic still life, but it is not anonymous. It bears the name of its owner, Melody. And it reveals Melody, one feels, as totally as does her face, in a severe portrait in which she peers out from under cropped, bleached hair, chilly and imperturbable, locking looks with the captivated viewer. In two images of her that I am told are fashion shots, she remains unmoved, while her male admirers adopt the abject position of slaves, embodying perhaps the prayer and promise of all fashion photographs. In one, a naked man who has been granted the privilege of touching her thigh lies at her feet. The man's name—Paul Wadina—is disclosed, which implies

33

34

Annamirl, 1984

his willingness to be identified with his posture, as if he were there not as a model but as a participant in a fantasy. One feels that there is a bond between Melody and Paul Wadina, and between them and the photographer, as if he had been allowed into a private space in which they were enacting some ritual of subjugation and power. It is a *pas de trois* of art and sexual insinuation.

Whatever the case with Melody and Paul, the subjects of Mapplethorpe's erotic photographs are usually not models in studio depictions of kinky kinds of sex. The people in these photographs are demonstrating something they have allowed the artist to witness, not as a voyeur, but as the agent through which the ordinarily hidden is revealed as art. The images are disclosures of sexual truth.

It might occur to someone that the formality of Mapplethorpe's photographs of women is a metaphor for his detachment from women as sexual objects, in the way that Winogrand's agitated approach is a metaphor for his own yearning. It is true that Mapplethorpe confessed to finding women unexciting as subjects, and this doubtless can be explained by the fact that they had ceased to engage him sexually. But the relationship Mapplethorpe entered into with his female subjects is not that different from the one entered into when his subjects were male, not even when it is plain from the men's costumes, stances,

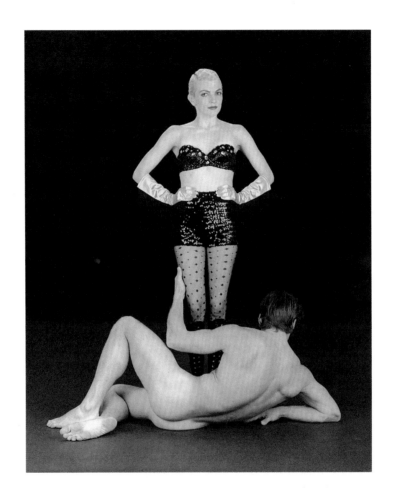

Melody and Paul Wadina, 1988

and demeanors that they are participants in the chain-and-leather form of sexual life Mapplethorpe himself partook of. The men are treated with the same dignity and distance, and accorded the same artistic respect that we find in every image in *Some Women*. The bond between artist and subject is apparent even in the somewhat untypical photograph of Brian Ridley and Lyle Heeter taken in 1979. This photograph is untypical because it is unsettling in the way a Diane Arbus photograph is. It is a shocking photograph, and it would be shocking even if it were more Mapplethorpian, by which I mean more centrally composed, more abstractly situated. One of the men is chained and shackled and in the power of the other, who stands above him, as proprietary as a new husband in a wedding daguerreotype, holding the rings of the seated man's chains in the delicate grasp of his gauntleted hand. They look as if this were the most natural thing in the world for them to be doing in their middle-class living room. There are draperies, venetian blinds, an oriental carpet, a cameo glass collection. An ornamental clock reads ten minutes to seven. A table lamp projects the shadow of the master figure onto the wall, behind the head of the slave. There are even magazines and a book on the table. If these were pornographic magazines—it is impossible to tell—then the neatness of their arrangement and display would be as dissonant with their content as the cruel crop and master's hat is with the domestic propriety of the space. What

Melody, 1987

is a sexual slave doing sitting that way in a comfortable armchair? Sadists in the living room. One is reminded of Goya's sentiment that the sleep of reason releases monsters.

It is possible to imagine alternatives to this image. It is not difficult, for example, to imagine a Winogrand-like photograph in which the men were caught off guard in their sadomasochistic paraphernalia. Angle and lighting would then convey an absence of agreement between artist and subjects. Or we could imagine a staged photograph taken for some magazine whose readers are stimulated by this sort of image. Models who in their own lives may or may not have shared the lifestyle that is suggested would have agreed to pose in exchange for a fee. We could infer nothing about them as individuals from the way they were arranged by the photographer. But Mapplethorpe's photograph of Ridley and Heeter is altogether different from such cases. Here, the subjects *are* what they consented to be shown as. They have disclosed their names. The photographer shares a moral space with them: they have admitted him into their room. And there is a sense in which the art belongs to the form of life it represents. They are connected through trust. Mapplethorpe was perfectly clear about this connection.

In an interview with Dominick Dunne in *Vanity Fair* magazine, Mapplethorpe said, "Most of the people in S&M were proud of what they were

40

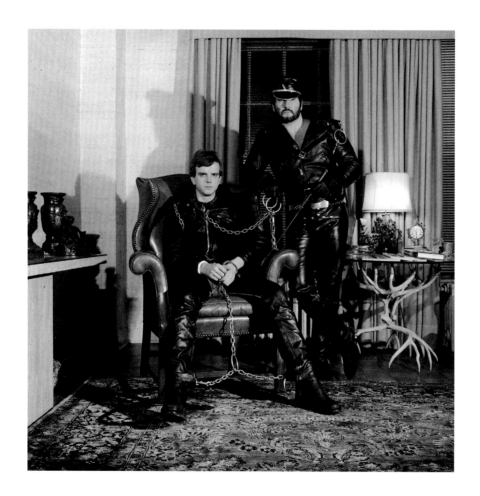

Brian Ridley and Lyle Heeter, 1979

doing. It was giving pleasure to one another. It was not about hurting. It was sort of an art. . . . It was pleasure, even though it looked painful. Doing things to people who don't want it done to them is not sexy to me. The people in my pictures were doing it because they wanted to. No one was forced into it. For me, S&M means sex and magic, not sadomasochism. It was all about trust."[3]

This component of trust is worth stressing, even if it is somewhat disingenuous to suppose there were not those who exploited the opportunities for cruelty and even brutality in the clearly dangerous gay world of the late seventies. It would be disingenuous not to admit that there were those who entered it for the risk of not coming out intact, for whom the sharp taste of pain and worse was a necessary condiment. And possibly there always was the threat of true danger even when the partners were consenting adults. Nevertheless, if Mapplethorpe is right, there was, as there characteristically is in the most conventional sexual interaction, a presumption that one's partner could be trusted. This is the basic connection between sex and love. We believe that those we love will have our well-being always in mind, which enables us to surrender to them in the physical act of sex without being afraid of harm. The implication is that certain limits will be respected, especially when we are at our most vulnerable in the dangerous zones of erotic engage-

ment. This defines the moral dimension of sex, putting to one side the issue of reproduction, which is in any case irrelevant in gay sex, and the issue of venereal disease, relevant to gay sex in ways as yet undreamed of in the heady days of the seventies. I suppose the "trust" Mapplethorpe makes so much of must connect with the spontaneous human appetite for feeling danger and being protected at once, like the child who finds it delicious to be thrown in the air, certain his father will not let him fall, or like those who seek thrills at amusement parks where they can be scared and at the same time know they are perfectly safe.

42

Mapplethorpe frequently remarked on what he perceived as a continuity between sex and art as he practiced it—in an interview with William Ruehlmann in the Norfolk *Ledger-Star,* he said that "to me sex is one of the highest artistic acts"—and he meant this in a number of ways, the least important of which has to do with sexual skill and finesse.[4] One dimension of it has precisely to do with trust, which is what connects the genre of photographs to which *Brian Ridley and Lyle Heeter* belongs to the body of portraits and studies of women in *Some Women.* Ridley and Heeter knew that Mapplethorpe was an insider, that he accepted them for what they were and perhaps even admired them. They could display their leather gear and shiny chains with pride. They trusted the artist not to make them look like fools, to show them as they

would wish to be shown, or in a way they could not have imagined but would be pleased with. For in the end there is always something in the photographic act that cannot be anticipated, a kind of unforeseen magic. "Magic" was a frequent term in Mapplethorpe's discourse, and we have no better word for stating what makes his photographs so remarkable.

Mapplethorpe was, so far as the world he moved in is concerned, what anthropologists call a "participant observer," a term that requires qualification but is useful in establishing that Mapplethorpe did not hide behind his camera, or remain outside the life he observed. Christopher Isherwood used the phrase "I am a camera" as the title of a story that records life in a decadent Berlin underworld as perceived by someone who felt himself to be almost completely an outsider. Mapplethorpe was not in this sense a "camera" at all. "Basically life is more interesting without a camera," he told an interviewer for *Splash* magazine. "I take pictures and it adds to my life. If I had a choice of photographing the party or going to the party, I'd certainly go to the party."[5] It is this that finally sets him apart from photographers like Winogrand or Cartier-Bresson, or even Diane Arbus. With Arbus, one feels, over and over again, that she found ways of betraying the trust that permitted her to get the pictures we see. There is something vaguely exploitative about her work. Cartier-Bresson was primarily a stalker, an eye attached to a marvelous

44

Henri Cartier-Bresson, *Alicante, Spain*, 1937

set of reflexes, which enabled him to pounce when reality disclosed something truly extraordinary—when reality opened up, one might say, with the speed of a shutter, to reveal a glimpse of some kind of underlying objective magic, or what his artistic peers designated *surréalité*. In order to do that, one feels, Cartier-Bresson had to make himself virtually invisible. He was almost metaphysically an outsider, and the men and women in his photographs don't acknowledge that he is there.

Arbus may have been a lonely person, even a pathologically lonely person, and one senses from her photographs that she did not have the trusting connection with her subjects that would have overcome the loneliness. Cartier-Bresson was almost of another order of being from the people he stalked. Winogrand's loneliness is patent in his photographs of women: his camera connects him to a reality to which he cannot be joined in the way he would want to be. The women will never be "his" except as unwitting or unwilling images. But Mapplethorpe was never outside the human reality of the photographic transaction. For him the transaction was a bond and presupposes a bond. That is what enabled him to produce some of the most shocking and indeed some of the most dangerous images in modern photography, or even in the history of art—for the kind of relationship he succeeded in realizing would have been unavailable before the invention of photography.

It is widely appreciated that the camera is a sort of detached eye, the mechanisms of which are analogous to the mechanisms of the human eye. And it is a natural extension of the language of the eye as a mechanical system that photographic images should be thought of as analogous to optical images, images that impose themselves on the retina, which cannot help but register what is seen. Indeed, it was held to be a mark of objectivity by early modern philosophers, concerned to distinguish imagination from perception, that the latter is not subject to the will. We can (at least if we are healthy) control our mental images, and hold them up for scrutiny in the private gallery of the mind, as when we fantasize or visualize or memorize. But we have no parallel control over our sensations, which are affected from without. It is this inherent absence of will that vests the eye with the status of a kind of witness, a recorder, a monitor, a registrar. And when one says of oneself that one is "only a camera," that is tantamount to saying one is but an eye: one registers what is there, what would have been there whether one had seen it or not. And that, as an eye or a camera, one makes no contribution to the visual array, and in particular that one does not judge.

Perhaps pictures have always had this implicit testimonial authority, even when drawn or painted, implying a direct cognitive engagement with the real, so that we who see the picture believe ourselves to be seeing exactly what the

artist saw. But there is another system of knowledge connected with the eye, one that is more concerned with the relationship between the internal world and its external expression than with the relationship between the external world and its mechanical registration on a receptive surface. In this system of knowledge, the eyes are, as the saying goes, the windows of the soul. Here too a reference to the will is perhaps in order. Through our eyes we reveal, cannot help but reveal, our true selves. What would not have been recognized until the camera underwent a certain technological evolution is that there is also this further analogy between it and the eye. The photographer reveals himself through the way he shows the world. The photograph is accordingly an intermingling, as complex as the intermingling between body and soul, between object and subject. To read a photograph is inevitably and inextricably to read the mind and self of the photographer, as well as to perceive a visual record of the way the world appeared at the moment the photograph was made. We learn about the photographer through his choice of subject, the way the subject is addressed, and from what is revealed about his attitude toward the subject and toward the mission of photography. A photograph is, in effect, a kind of writing, in which, in addition to whatever truth is written down, the writer discloses to the eye of the handwriting analyst as much about himself as about the subject of his inscription.

Since style and personality are revealed through the images an artist produces and are not a matter of will (by contrast perhaps with a *manner*), it would be reasonable to suppose that what we find in the work of various photographers we would find in other aspects of their lives. I find it difficult to imagine that Cartier-Bresson or Diane Arbus would be greatly different in their personal relationships from the ways their art shows them to be. I feel I know, for example, what it would be like to enter into an extra-photographic relationship with either of them. In the case of Mapplethorpe, my sense, right or wrong, is that I would be able to trust him as a person because trust is so central to his style of photographic address, and to so high a degree a condition of the implicit contract between him as artist and his subjects. To be sure, there is an element of artifice in any studio setup. The subject is arranged in a certain way before the camera, and against a certain backdrop. Light and shadow are orchestrated. This artifice is nonetheless wholly consistent with objective truth, particularly if one feels that that truth has to be found, that it is not on the surface, that the manipulation of light and shadow, for example, is a method of searching for a truth the artist will know when it is revealed. The undeniable presence of studio artifice in Mapplethorpe's photographs has nevertheless given Mapplethorpe the reputation of being a kind of *pompier* photographer, stagey and academic and

concerned with effect. And it is not difficult to see how this critical attitude should have evolved, particularly if one contrasts Mapplethorpe with someone like Winogrand. The willed accidentality in Winogrand's photographs, and the apparent dependence on chance and luck, make it easy to treat his works as if they were unstudied, like snapshots. Winogrand resisted that characterization, perhaps rightly, but the signature "tilt" of his frame, which refers to the mechanism of the camera and the angle it was in when the subject was shot, or the way parts of certain figures are chopped off by the frame (rather than carefully cropped in the interest of composition), defines a rhetoric of naturalness, spontaneity, and directness, qualities that would be admired by someone who might then denigrate Mapplethorpe for artifice. Both Arbus and Cartier-Bresson can say, in all sincerity, that the subject did not know she or he was being "taken."

The snapshot is the emblem of the guileless photographer who merely aims and clicks. The basic structure of the snapshot is this: the subject of the photograph—that which the picture is *of*—causes the image to resemble it because of the laws of photochemistry. Causality and resemblance leave no room for artistic intervention: what you get is what you see. The format of the snapshot, therefore, gives those photographers who aspire to be taken as direct, sincere, and honest a manner of working that may not in fact be

especially honest at all. There is no way of confusing a Mapplethorpe photograph with a snapshot.

Another factor that may account for negative critical assessment of Mapplethorpe's work has to do with the subjects he chose for portraits. "Almost all of your sitters have *chic* in common," an interviewer observed. "You don't have any portraits of cocktail waitresses or taxicab drivers." Mapplethorpe agreed. "No, I'm not interested in those people," he replied. "The Nicholas Nixon people. Plain people." He offered as a possible explanation for this that such people belong to the world he grew up in and that "I know what they're like."[6] Which implies that for him the camera is to be an instrument of exploration. But the choice of rich, famous, and beautiful subjects carries a certain political weight in an age in which chic is at once envied and condemned. The immigrant, the sharecropper, the sweatshop worker, the manual laborer make up the dramatis personae of traditional artistic photography in America. For artists such as Alfred Stieglitz, Lewis Hine, Dorothea Lange, and Walker Evans the intention of such photography was political, not exploratory, and its goal was to change the attitudes of viewers.

The duty of photographers to execute political imperatives is still so much a given that the recent trend toward turning one's camera on the world of middle-class family life has been viewed as a kind of dereliction—a "with-

drawal from the world's conspicuous problems" in the words of Peter Galassi, curator of photography at the Museum of Modern Art in New York.[7] And the artists so engaged would undoubtedly respond that they are not celebrating but criticizing bourgeois values. An exhibition of such work, presented by Galassi at MoMA, was called "Pleasures and Terrors of Domestic Comfort," as if the presence of "terror" went some distance in extenuating the subject. When, by contrast, the subject is chic and the photographer is chic as well, it is surprising, in an art world in which certain political attitudes are de rigueur, that Mapplethorpe has not been more fiercely put down as an aesthetic snob. Perhaps his political acceptability, in consequence of the martyrdom of his art in connection with right-wing attacks on institutions that support it, has redeemed him in the politicized and judgmental eyes of an art world whose values are otherwise so antithetical to those proclaimed by his style and typical subject.

Sam Wagstaff, Mapplethorpe's great admirer, sometime lover, and constant benefactor and mentor, wrote that the artist "allows himself one trick in his act and that is the drama of light."[8] But Mapplethorpe's lighting is a "trick" only against a concept of natural light that, like the rain, falls indifferently on both poor and chic. Or, if it is a trick, so is natural light a trick, with its

own set of meanings. There is no visual world without shadows and light, and the subject has to be the locus of shadow-and-light play wherever photographed, indoors or out. In a sense, Mapplethorpe's lighting is so conspicuously nonnatural that it emphasizes the fact that the work took place in the studio, which uniquely allows that form of manipulation, and hence is based on an agreement between artist and sitter, who have entered into a relationship of trust for the sake of an image. And it emphasizes that this is art, and not the chance registration of a fortuitous image.

Mapplethorpe's ability to instill trust within the photographic situation must have been among his greatest gifts, and one might consider the self-portraits from this point of view. Susan Sontag quotes Mapplethorpe as saying that his self-portraits express that part of him that is most self-confident, and "confidence" is a near-synonym for trust.[9] It is difficult, in contrast, to see how the philosophies of photography one associates with Arbus or Winogrand would have been consistent with their taking pictures of themselves, let alone self-*portraits*. Winogrand could possibly have set things up so that an image would be registered when he tripped the shutter by accident, on his way to the kitchen for a beer, and so took himself unawares, as if an Other to himself. (This is a possibility peculiar to photography: no one could paint himself unawares.) It is difficult to imagine how Cartier-Bresson might

watch for the unselfconscious disclosure, because that again would require a distance from himself that would similarly turn him into an Other to himself. And how could Arbus betray and at the same time be at one with herself?

In a sense, Mapplethorpe undertook to establish the kind of relationship with others that he had toward himself. His photographs in both cases were explorations and revelations and risks. In one of his illustrations for an edition of Rimbaud's *A Season in Hell,* he portrayed himself with horns, as a kind of devil. Images of devils figure widely in his private iconography—he owned cuff links and ceramics and other objects decorated with images of devils, we see devils tattooed on various arms in his photographs of scary men, there are devils as statuary or bric-a-brac in different interiors he shot. Devils vie only with skulls as most favored ornaments in Mapplethorpe's world. But in this image for Rimbaud's poem, he set himself up with horns in the same spirit of exploration that animates his entire photographic undertaking.

The same is true of his portrait of himself as a woman in furs. He wanted to have the experience of looking like a woman. He was not, so far as I can tell, looking for a feminine identity, as Marcel Duchamp did with Rrose Sélavy—not even though eros was far and away the most important thing in Mapplethorpe's life, as he freely confessed in many interviews and as is powerfully attested to in his art. When he was asked once if anything was sacred

Self-portrait, 1980

to him, he answered, "Sex." But the answer could not be as flippant as the question undoubtedly was. Mapplethorpe was probably incapable of flippancy. He was remorselessly sincere. In a video made for Spanish television, Sam Wagstaff said that Mapplethorpe was the most honest person he had ever known. This is borne out in the interviews. Mapplethorpe is unflinching. One cannot read very many of them without being struck by his absolute candor. He never dodges a question. It is this honesty that characterizes the self-portraits as well. Even when he got himself up as a devil or a girl, or a punk, it was in the interest of discovery and personal truth.

It is instructive to compare Mapplethorpe's self-portraits with the work of Cindy Sherman, his contemporary and occasional subject. The bond of confidence that connected Mapplethorpe with others in photographic transactions seems to have connected Sherman only with herself, and even then some essential shyness inhibits her from showing herself as she really looks. In Sherman's stunning series of mock-historical portraits of the late eighties, in which she puts herself in the pictorial situation of a nursing Madonna or of the mistress of Raphael, the artist never, so far as I know, shows her own nakedness, though many of the subjects are in fact nude. There are always breasts and bellies as transparently false as the noses and mustaches. This often makes the photographs extremely funny and at the same time extremely

55

Cindy Sherman, *Untitled*, 1989

witty; in Sherman's version of Raphael's *La Fornarina* she wears what she calls "false tits" that are as protective of her own bosom as if she were wearing the chest protector of a baseball catcher. Mapplethorpe, incidentally, rarely elicits amusement, though he claimed there is a sense of humor in his work, and it pleased him when people saw it. Sherman leaves it a puzzle as to what she looks like, but whether wearing horns or furs, or made up like a vulnerable and coltish young girl, Mapplethorpe is always transparently himself. The nakedness is always his nakedness.

And the risks are always his risks. The notorious self-portrait of himself from behind, in leather chaps and cowboy boots with a bullwhip stuck in his hairy anus and looping out onto the floor like a rat's tail, *may* have been intended as funny. The artist looks back at the viewer with a complex expression—glowering if one looks at the eyes, about to break into a smile if one looks at the mouth. The humor does not easily override the shock this image induces, however. There are plenty of male behinds in the history of art, but there can be relatively few anuses in that history, roughly for the same reason that while there are whole battalions of female nudes, there are relatively few displayed vaginas. The vagina does not show itself the way the penis does in the frontally presented nude figure, and can be seen only when the body is specially arranged to show it—only when the woman spreads her legs, as

58

Self-portrait, 1978

in the famous painting by Courbet rather pompously titled *The Origin of the Universe*. And so it is with the anus: the buttocks must be spread apart. Picasso only occasionally drew anuses, like little stars or spiders, and one might plausibly argue that the contortions cubism imposes on the human body might in Picasso's case have been invented so that he could show the orifices as a matter of course. But Mapplethorpe's self-portrait goes well beyond flashing a rarely shown orifice. He shows it as penetrable and hence as sexualized. The instrument of penetration here is also an instrument of cruelty and punishment, an object of masochistic fantasy, an analogue to the immense penises that appear over and over again in Mapplethorpe's corpus. The elements of a kind of uncomfortable comedy are also present in this photograph, and there may indeed be those who find it funny. Still, its title is *Self-portrait,* in case there should be any doubt, and there is nothing false about the image: that is a real whip being pushed autoerotically up a real anus.

The question of the trust inherent in the artist-subject relationship becomes somewhat problematic in the case of children. This has been at the core of much debate vis-à-vis a 1976 photograph of a little girl named Rosie (sometimes, confusingly, referred to as "Honey"), who is shown sitting on an ornamental garden bench with her dress pulled up in such a way as to reveal

59

her genital opening. Perhaps the dress fell that way by accident, perhaps she was told to pull it up, perhaps the artist or even the child's mother arranged it. There is a question of the degree to which the child knew she was exposing herself, or what the knowledge might have meant to a two- or three-year-old. Of course, it is widely accepted, since Freud if not since Saint Augustine, that children are not quite so sexually innocent as idealized conceptions of childhood would have it. (Françoise Gilot records that when Picasso made his well-known *Goat*, it would not have been in the artist's character to have left the anus out, which in the actual work consisted of a short length of metal pipe. I once watched children troop past the piece at an exhibition in Paris, and they unfailingly looked under the tail and giggled.) What children are innocent of is *adult* sexuality, including those aspects of adult sexuality in which children can be sexual objects in ways they cannot be for one another. I am not certain of how the expression on Rosie's face is to be read. It could be childish abstractedness, or it could be uncertainty with a hint of fear. In any case, one cannot avoid feeling uncomfortable with the photograph. Rosie is not proud of her sexuality—she does not know her body the way the body-builder Lisa Lyon knows *her* body, to take an extreme example. And there is the question of whether Mapplethorpe saw her in that pose and decided to shoot her, or whether he put her in the pose for the sake of getting the shot

of a child's sex. In an interview in *Open City*, Mapplethorpe said, "I don't want somebody to take their clothes off if they don't want to take their clothes off. I remember when I was a kid I was sort of coerced into something like that—it was a horrible experience."[10] He repeated the recollection in an interview with Gary Indiana: "I found myself in a situation with a dirty old man wanting to do nudes and being pushy, pulling my clothes off, it was horrible. I would never do that to somebody."[11] Still, since children are not moral agents, there can be no presupposition of trust, save in the somewhat generalized sense in which children trust adults without there being the slightest possibility of adults trusting children, which probably explains why Mapplethorpe felt uncomfortable photographing children.

Rosie was one of the controversial photographs in "The Perfect Moment," an exhibition organized by Janet Kardon that opened at the Institute of Contemporary Art at the University of Pennsylvania in December 1988. The show gained notoriety when the director of the Corcoran Gallery of Art in Washington, D.C., canceled its scheduled run there in the summer of 1989 because she feared that Congress would object to an institution funded by the National Endowment for the Arts sponsoring an exhibition that could be construed as obscene. "We really felt this exhibit was at the wrong place at the wrong time," the director, Christina Orr-Cahall, said later. "We had the

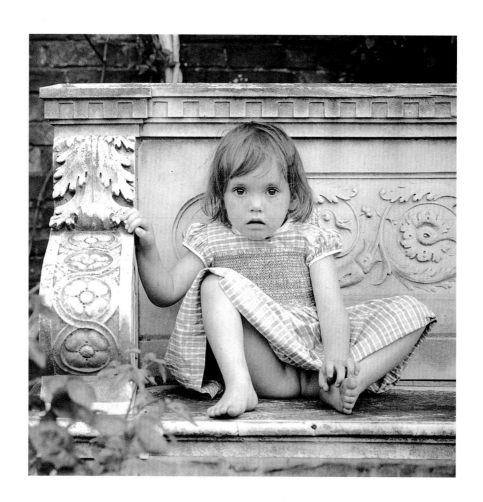

Rosie, 1976

strong potential to become some person's political platform."[12] But the cancellation in fact precipitated the firestorm of controversy that Orr-Cahall had been seeking to head off. Senator Jesse Helms of North Carolina led a right-wing attack on the National Endowment in Congress, and members of the religious right initiated a letter campaign against government spending on blasphemous works of "so-called" art. By the spring of 1990, when "The Perfect Moment" arrived at the Contemporary Arts Center in Cincinnati, the atmosphere surrounding it had become extremely volatile. Police entered the gallery and closed it temporarily while they secured evidence with which to prosecute its director, Dennis Barrie, for "pandering obscenity" and exhibiting child pornography. Barrie and the arts center were later acquitted.

It is somewhat surprising that *Rosie* was reproduced in the catalog for "The Perfect Moment." The printer of the catalog for the Mapplethorpe retrospective at the Whitney Museum of Art in 1988 had refused to include a picture of a young girl whose genitals are shown, and he was undoubtedly prudent to do so. The prohibition against photographs showing a child's genitals in a lascivious manner was the one legal achievement of the Reagan administration's Meese Commission on Pornography. There is in fact a certain hysteria on the topic of sexual exploitation of children. In 1990, federal agents in California seized photographs of nude children from the studio of Jock

Sturges, who had been documenting a number of nudist families over the years. They made off with much of his work, his laboratory equipment, address books, etc., although no indictment was ever returned. The "pandering" charges against Dennis Barrie in Cincinnati could be made because of the narrow definition of the crime under Ohio law: displaying children's sexual parts. It is ironic that the arts section of the *New York Times* for April 24, 1990, which published an article on the Cincinnati trial, also printed, next to it, a story about the Johnson Collection of Sacred Art, then being circulated in Poland. The story on the Johnson Collection was illustrated with a reproduction of Bellini's *Madonna and Child with Donor*. The infant Jesus is depicted with a bare penis, as much an emblem of the enfleshment of God as could be wished for. It is reasonably plain that Bellini did not paint his naked boy with the intention of arousing prurient interests, but it is not plain that Mapplethorpe intended to arouse prurient interests in photographing Rosie. Is it just a little girl with her skirt up? Does it make a difference that one is a photograph and the other a painting?

There may be a sense in which photography more than painting is susceptible to the charge of exploiting children, and the issue rests on the fact that a person is actually present when a photograph is made. Bellini may or may not have used a model, but there is no serious alternative in the case of

a photograph. The question then arises as to whether some psychological harm may be done to a child when photographing her genitals. It is this possibility, for example, that concerns legal theorists caught up with the issue of freedom of expression. It does not matter whether the child was unconscious of the fact, or the meaning of the fact, that her genitals were exposed and being photographed. It does not matter whether she was "innocent," or unconscious: the experience could still have been traumatic. Freud identifies an interesting phenomenon he designates as *Nachträglichkeit*, in which an experience, not traumatic at the time it occurred, is retroactively made traumatic by a later, similar experience. His example is a girl whose genitals were fondled by a storekeeper, which at the time made no particular impact. But, some years later, when a similar event took place, the earlier, neutral experience was recalled by the now older girl as molestation. In psychoanalyzing her, Freud had to find his way to the earlier episode. This is the way in which harm might have been done to Rosie, and though the photograph might not be especially conducive to pruriency—and though another one, in which she were wearing underpants, might be more conducive—a legal thinker could argue that there is a shadow of harm in photographing a child that would not arise with an adult. Of course we know too little to say for sure. Ingrid Sischy, in an article on Mapplethorpe in the *New Yorker*, talked with a young man, Jesse

66

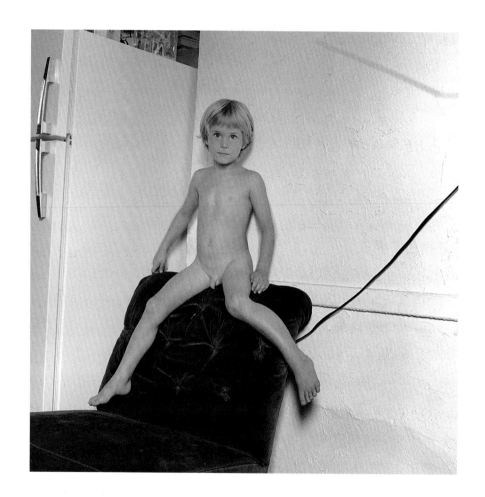

Jesse McBride, 1976

McBride, who fourteen years before had been the nude subject of one of Mapplethorpe's photographs. McBride felt no untoward effects. Still, I suspect, each case is likely to be different. And who knows, if there is anything to Freud's notion of *Nachträglichkeit*, what the retroactive effect would be on having been photographed nude as a child if one were photographed nude as an adult? *That* would be an argument against the nude photographing of even consenting adults! My own sense is that the case for actual harm rests too uncertainly on psychological premises that themselves are uncertain. So the objections against *Rosie* must finally rest on grounds of taste and moral attitude.

A somewhat different line of argument has been advanced by certain feminist theorists, particularly in connection with images of women that show them in positions of degradation. These images, the argument runs, are actually harmful through the fact that they violate the civil rights of women. This is formulated in the so-called Minnesota Ordinance, whose primary author is the legal theorist Catharine MacKinnon. She makes the novel claim that these images, just as images, subordinate their subjects. It used to be thought that such images were dangerous because they could cause real victims to be harmed—could *inspire* actual episodes in which women were "subordinated," to use her term. But MacKinnon would claim that the very fact

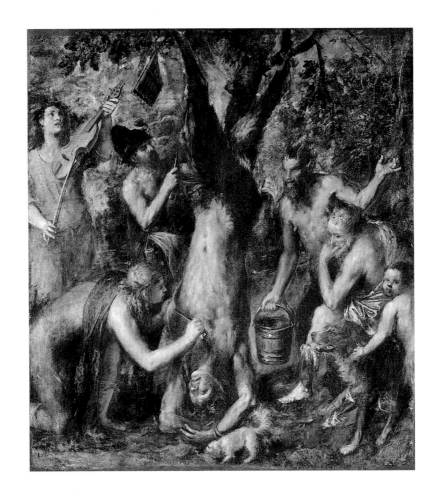

68

Titian, *The Flaying of Marsyas*, c. 1570–1575

of being represented in certain ways subordinates the subject represented, even if such images were shown to do nothing to stimulate aggressive sexual acts against women, or were shown in fact to reduce the likelihood of such acts by vicariously gratifying the desire to perform them. Fortunately, this argument, however compelling, removes any special stigma from photography: the Minnesota Ordinance speaks of pictures and words, and the pictures could as easily be drawings or paintings or computer graphics as photographs. Moreover, the ordinance was struck down as in conflict with our First Amendment rights. And in discussing the issue of rights to free expression, one must think not only of the artist and the viewer: one must, in Mapplethorpe's case, think as well of the subjects' freedom to have themselves shown in certain ways. Would it be a violation of the rights of chained masochists to ban photographs of them?

There is something quite extraordinary to most of us in the idea of someone wanting to be seen in the way in which Elliot and Dominick are posed in a photograph taken in 1979. Dominick is chained and trussed and hung upside down like the satyr in Titian's terrifying painting *The Flaying of Marsyas*, which, in point of sheer brutality, outdoes anything dreamed of by Mapplethorpe. Dominick's undershorts have been rolled up, and his penis is exposed. Elliot, stripped to the waist, holds Dominick's testicles with one hand,

70

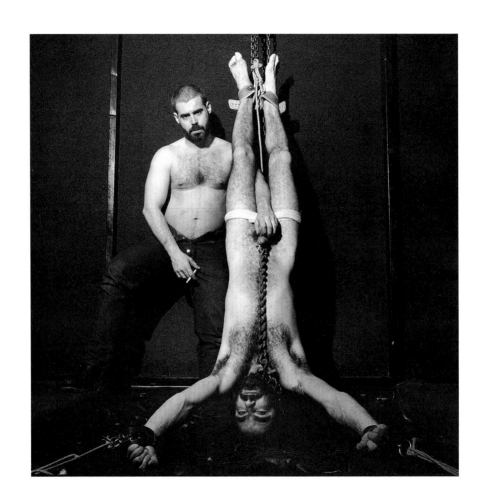

Elliot and Dominick, 1979

and a lighted cigarette in the other. And he looks extremely menacing. His may be a look as ritualized as the leather garments S&M practitioners wear, but even if we accept the claim that Dominick trusted Elliot, and allowed himself to be put in the position in which he was totally helpless, totally in Elliot's power, this is an extremely frightening image.

Elliot and Dominick is among the most difficult of Mapplethorpe's photographs, and it has been observed that had the scenario been heterosexual, it would have been intolerable, even if the female victim also "trusted" her partner, and wanted to feel what it was like to have her body completely accessible to his will. Perhaps what would be intolerable in such a case is the fact that women have been accused of "wanting" to be victims. (Which could in a sense justify MacKinnon's thesis.) The photograph is frightening, to be sure, in a different way from those paintings by Leon Golub of hooded and stripped victims, male and female, being interrogated in squalid quarters in guerrilla zones of the Third World, though Golub once revealed that he was dependent on illustrations in S&M magazines for his knowledge of how people being tortured look. And in fact Dominick looks somehow rather peaceful in his objectively nightmarish situation. Perhaps the difference lies in the fact that Golub's victims did not want to be in those situations, and Dominick did, and it is the desire we find frightening as much

71

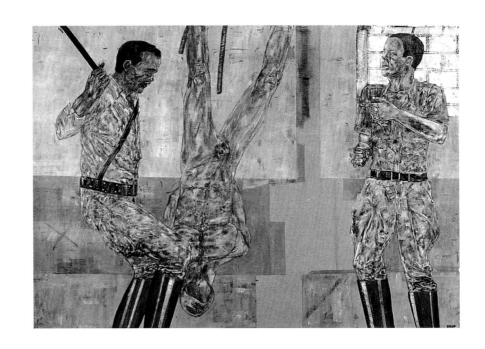

Leon Golub, *Interrogation I*, 1981

as the actual setup. Whatever the case, the difference between painting and photography comes out clearly when we think of a photographer depicting what Golub depicts: he would have to be there, present in the cell, photographing the torturers at their grisly work. And he would be somehow as morally reprehensible as they are. The *only* morally acceptable photograph would be a Winogrand-like candid shot, grainy and tilted, taken without the subjects knowing it was being taken.

We have to believe that, whatever was taking place between Elliot and Dominick, there is only the most outward resemblance between their situation and the ones depicted by Golub. Still, the similarities add an edge of danger to Elliot and Dominick's play. The image makes contact with something deep in the psyches of viewers, in a stratum where dreams are formed. What is shocking to most of us is that Elliot and Dominick, and so many others in Mapplethorpe's world, undertook to reenact what in the rest of us finds expression in fantasies, or in dreams. Freud's analysis of dreams is that they are "wish-fulfillments." These photographs also are wish-fulfillments of the individuals who enact their fantasies. This connects with MacKinnon's point: it is not merely the act but the representation of it which fulfills the wish. That is why these people went out of their way to get photographed. None of the photographs is exactly a document of what people did when they were not

being photographed (although there does exist a box of photographs at the Mapplethorpe archive, labeled SEX, which are). Elliot poses beside Dominick with the authority of a fisherman being photographed next to some immense tuna he has caught. Mapplethorpe told Gary Indiana that "they weren't people play-acting and doing something they hadn't done before they had put it together for that photo session."[13] He means: the game was earnest. Elliot and Dominick were not models. This is their portrait.

Pornography played a central role in Mapplethorpe's artistic mission, and it made him an artist of his own time in a particular way, perhaps *the* artist of his own time. In part this is because the world he made his own did not exist before, nor has it in that form in which he photographed it altogether survived him. The seventies was an era of liberation, a period dedicated to the casting down of barriers to free expression and to personal fulfillment, and this was especially true in the domain of sex. The pill enabled women to take responsibility for their own sexuality without the concerns for getting pregnant that had existed from time immemorial, and homosexuals were encouraged to declare their identities and to articulate their emotional and physical needs as a matter of civil right. Society was seen to have no power over sexual choices

beyond protecting the very innocent, which is perhaps why prohibitions against representing children as sexed beings persisted as a charged issue.

It is difficult to suppose that Mapplethorpe had any particularly well-formed political views. He was not an activist. His interests in sex were somehow more aesthetic and in a sense metaphysical and—despite the tautology—*sexual*. Even so, the politics of liberation made it possible for him to build a body of artistic work on what would largely have been forbidden themes as little as a decade earlier. If S&M devotees had been photographed at an earlier time, they would have been exposed to blackmail. Now they sought out Mapplethorpe as a photographer because their activities were ennobled as well as licensed. Artists have always created a certain amount of erotica, and a fairly extensive exhibition could be built up of the erotic works of the masters—of Titian, Carracci, Rembrandt, Courbet, Fragonard. But this work was marginal, for private delectation. There certainly had never been a major artist before Mapplethorpe for whom erotic imagery was central, or a time when pornographic images could claim status as high art. Until Mapplethorpe, the natural habitat for such imagery would have been the novelty shops along Forty-second Street in Manhattan, in crude magazines, for the private pleasure of fantasists.

Mapplethorpe often recalled seeing pornographic images in those shops when he was about sixteen—"not even old enough to buy them"—and an art student at the Pratt Institute. He repeated the story to Carol Squiers:

> I'd look in the window at those pictures and I'd get a feeling in my stomach. I was in art school then and I thought, God, if you could get that feeling across in a piece of art. . . . It was exciting but definitely forbidden. Because they were always in cellophane you couldn't get at them. Putting things over the pictures came partly from that, it veiled things a little bit and made them more unreachable. But I remember wanting to get that feeling across, which of course you can't, in the context of an art gallery.[14]

76

His ambition was to create images that would be as arousing as those in porn magazines, but artistic: to achieve "smut that is also art." In a sense, his photography attempted to reproduce the conditions of the kind of sexuality that it took as its subject. The aim of those who participated in S&M was to get as close to the kind of danger represented by the interrogation chamber as possible—to have the sour taste of fear, or the thrill—and yet not quite to cross the line into true victimization. People like Elliot and Dominick undertook, in Mapplethorpe's own phrase, to "play with the edge." In a perfectly analogous way, he played with the edge that separates art and mere pornog-

raphy mainly because he cherished the feeling the latter induced in him in those first powerful experiences with crude images. To subtract from Mapplethorpe's photographs, particularly those of the late seventies, but in a sense from any of the work, the sense of that danger and hence that feeling, is seriously to distort their aesthetics, and to misconceive his artistic agenda.

At the same time it is important to stress that Mapplethorpe, even early on, had no illusions about the power of certain images to arouse sexual excitement, in contrast with the power of art to elicit whatever feelings of aesthetic transport it is alleged to be capable of arousing. His ambition was to create work that really was pornographic by the criteria of sexual excitement, and really was art. And it incorporated the "edge." So the photographs could be printed in pornographic magazines by virtue of their effect, or in art magazines by virtue of their aesthetic power. In fact Mapplethorpe succeeded in both dimensions of this aspiration, though the images, were they to turn up in pornographic magazines, would be singular by virtue of their artistic discontinuity with the relatively mechanical representations of sexual postures conventionally found there. The more remarkable achievement was that he succeeded in getting these images into galleries, where the discontinuities were greater by far. "Anyway, I had the idea of taking sexual images and doing it a little differently than it had been done before," he told *Open City*.

77

"Having a formalist approach to it all, which I hadn't seen in photography or pornography. So I set out to do that."[15] Mapplethorpe at first used ready-made pornographic images, which he modified in various ways, as components in collages, for example, or smeared over with paint (which is what he referred to as "putting things over the pictures"). But he began to feel that he wanted to make his own images, and once he embarked on that route—doing his own pornography, so to speak—the extraphotographic devices of the earlier work—the overpainting, the collages—dropped away, and the program he described as "seeing things like they haven't been seen before" was in place.[16] He literally became a pornographer with high artistic aims.

The formalist aim pretty much precluded a Winograndian approach to content. "I think I was one of the first to really approach sexuality with an eye for lighting and composition and all the other considerations relative to a work of art," he told Mark Thompson of *The Advocate*. And yet, "I recorded it from the inside. . . . I guess all photographers are in a sense voyeurs. But I don't like voyeurs, people who don't experience the experience, who view life from the outside."[17] The formalist premise ruled out the voyeuristic look completely, and that meant that unless his subjects could hold their poses for a sustained period, as the lights were adjusted, the possibility of art as Mapplethorpe conceived of it was in jeopardy. In particular it meant that he could

rarely photograph his subjects *in flagrante*. The little photodocumentation of "live" sex he made resulted in some images that are pretty hard to take, perhaps because they go over the edge, and are unchecked by formalist constraints. Mapplethorpe himself evidently never flinched: "I was in a position then when I was relating pretty strongly to that form of sexuality. I felt I could get something out of that experience into photography that no one else had done before. It was a new territory without any rules."[18] He soon discovered one rule, however. Mapplethorpe told Dimitri Levas that sex was really not meant to be photographed. Bodies could not be controlled. He could not say to someone in ecstasy, "Hold that! That's it!" Without the formalism, the work goes over the edge. With it, the edge is driven back and sexuality becomes more tacit than actually witnessed.

In order to be in control, Mapplethorpe required his subjects' agreement, their knowledge, and, as emphasized, their trust. The moral relationship between subject and artist was a condition for the artistic form the images took. The formalism was connected to the content through the mediation of that moral relationship. To be sure, this may go no great distance in reducing one's moral disapproval of the work. The fact that there was the core of trust leaves the moral status of that kind of sexual conduct where it was. But my interest so far has only been to connect the conditions of making the photograph with

the form the photographs finally took. The edge need not be felt as excitement. It can be felt as shock or even revulsion. Perhaps for Mapplethorpe it was never merely excitement: "It was a feeling much stronger," he told *The Advocate*, "than just sexuality."[19]

There is a term used by Hegel to great effect in constructing the vast architecture of his philosophical system. The verb, in German, is *aufheben*, and it cannot be translated easily into English, mainly because it carries at least three distinct meanings: it can mean to negate, or to preserve, or to transcend. Hegel's use of the term fuses these three meanings: it is not an *Aufhebung* unless something is at the same time negated, preserved, and transcended. This is a useful concept with which to address the sexuality of Mapplethorpe's images. There is no getting around their content: it is what it is. But within the framework of the photographic it undergoes an *Aufhebung*. The content is preserved. But it is also negated, and it is transcended, and that means the work cannot *merely* be reduced to its content. The real task facing the critic is to account for whatever is left over when, so to speak, he subtracts from the works their content on the grounds that the edge between them and pornographic images remains integral to the art.

Consider, for the sake of an exercise, the painting of *Madonna and Child with Donor* by Bellini, as it was reproduced in the arts section of the *New*

York Times. It is, conspicuously, a representation of an unambiguously gendered infant. That is its content, and if there were a general prohibition against the representation of children as gendered, this would be a forbidden image. The iconoclast could justify its destruction because it is an image of a certain sort—an image of a penis. But the Bellini is also a work of art, painted by a great master. And that negates its status as merely depictive. It is so much more than depictive that those who see it as art may be blind to the content that obsesses the iconoclast, and not even notice that the Holy Infant is gendered. Leo Steinberg was referring to this in his powerful study of Christ's sexuality in Renaissance art and its "modern oblivion."

It is, I think, not at all hard to appreciate the difference between the iconoclast and the aesthete if we attend to certain facts about perception, as studied by those philosophers known as phenomenologists. Jean-Paul Sartre, for example, writes about someone who encounters a cliff: "For the simple traveler who passes over this road and whose free project is a pure aesthetic ordering of the landscape, the crag is not revealed either as scalable or as not-scalable."[20] It is scalable or not-scalable only to someone whose "free project" is not aesthetic but practical—someone who wants to get somewhere, and who must climb the cliff or walk around it. The world reveals itself to us differently depending upon our project. To the moralist, all that matters

is whether the painted baby is wearing a diaper. To the aesthete, the baby does not reveal itself as sexed at all: what outrages the iconoclast is invisible to the aesthete. The advantage of thinking in terms of *Aufhebung* is that we must keep both dimensions in mind at once. There is the energy of the displayed sex, and there is its containment, its absorption, into the work of art. It is preserved and negated in the same moment.

But it is also transcended. Something differentiates the Bellini panel from mere formal design, after all. The work portrays a god enfleshed, innocent and yet showing the attributes through which the flesh is corruptible. The kneeling donor is not after all worshiping a baby: he is acknowledging a miracle, namely the ingression of a transcendent being into a material finite body, subject to suffering, and to pain. And just as Christ is both flesh and divinity yet neither, the painting is both matter and meaning yet neither. It embodies a message of redemption and salvation and purification. But, paradoxically, the baby must be conspicuously flesh in order to address the viewer at the highest level of religious art. Leo Steinberg's point, or one of his many profound points, was that Christ could not have the moral authority he carried had he not also been man—and he could not be man and ungendered. He could in particular not have been chaste without sexual capacity. The sexual

being of the enfleshed god is thematized in Bellini's image. It is a marvelous example of sexual truth preserved, negated, and transcended.

It is interesting to look at one of Mapplethorpe's most notorious photographs in this light. *Jim and Tom, Sausalito* shows one man urinating into the mouth of another—or one man drinking the urine of another, since the act seems wholly voluntary. This photograph was the focus of a great deal of particularly vehement condemnation in 1990, when the debates over extension of the National Endowment for the Arts were fueled by the precautionary but disastrous cancellation of the Corcoran venue of "The Perfect Moment." The transformations in American society between 1965, when the Endowment was funded, and 1990, when the issue of its extension became a matter of fierce debate, coincided with as considerable an upheaval in moral sensibility as the nation has ever known. It was a quarter century of intense moral experimentation. There was a parallel transformation in artistic production in that period, as well as in the reception to art. Mapplethorpe exemplifies both transformations. His life and his art together would have been inconceivable at any earlier time. The decision to "play with the edge"—to insinuate into the heart of high art a morally impugnable content—is in effect the emblem of both transformations.

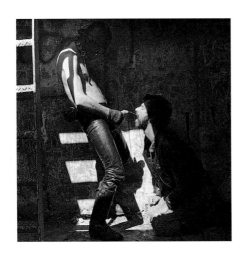
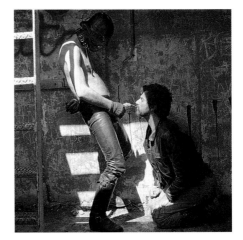

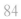

Jim and Tom, Sausalito, 1977

© 1977 THE ESTATE OF

ROBERT MAPPLETHORPE

In 1965, art was widely regarded as an enhancement of the spiritual well-being of the citizenry, a good of perhaps the highest order a secular society can endorse, short of the goods that define that society, namely, liberty, equality, and the like. Artistic freedom in America was pointedly contrasted with the way artistic expression had been suppressed and censored in societies America had been at war with, or with which it was at the time in an essentially "cold war." There was still among those concerned with art the memory of the way the Nazis had burned books, and how they had forbidden as degenerate much of modern art.

What no one anticipated was that artistic freedom would be exercised in anything except a "high-minded" way. All of this changed, however, with the revolution in social morality, and especially sexual morality, through the late sixties and into the seventies. Artistic representations of a kind that would have previously been covert became more and more overt. And for no artist was the question of sexual content more central to the very substance of his artistic project than for Robert Mapplethorpe. In this sense he was exactly the right focus for the controversy over federal funding of the arts. In opposing Mapplethorpe's art, critics were opposing the change in art and, more deeply, the change in morals which made the art possible. Very few of Mapplethorpe's critics in Congress, perhaps none, came forward to defend Mapplethorpe as

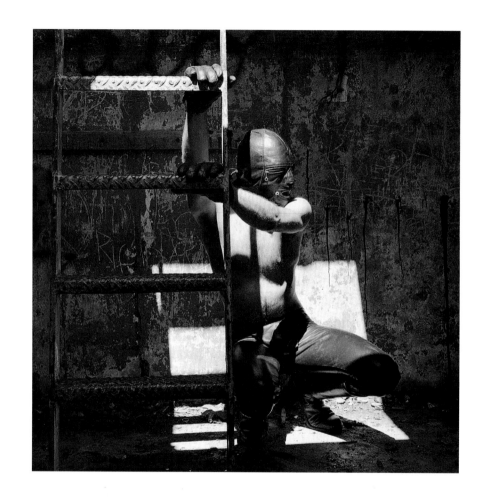

Jim, Sausalito, 1977

an artist, save insofar as he might be protected in some abstract way by the principles of artistic freedom. It is against this debate that *Jim and Tom, Sausalito* must be appreciated now.

There can have been few antecedents in the history of art for this image, unless in a corner of some sixteenth-century depiction of Hell. And outside what Gibbon described sententiously as the "decent obscurity of a learned tongue," there can be few descriptions of the act photographed, even in the kind of book Krafft-Ebing's *Psychopathia Sexualis* exemplifies. It is small wonder outraged legislators could not see in this morally difficult work anything except its content. Their attitude was essentially that of the cross-examiner, insisting that the witness say whether or not—no ifs, ands, or buts—this is a photograph of one man urinating in another man's mouth. But no appreciation of the work that failed to preserve that reading, which is undeniable, could be acceptable, even if there are unquestionably certain formal considerations that negate it as *mere* pornography. *Jim and Tom, Sausalito* is in the form of a triptych, with three shots of as many stages in this act of discharge. Jim is wearing S&M regalia—the leather pants, the boots, and a menacing leather hood, with zippered eye slits and mouth opening, and gauntlets. We have a very clear image of Jim from another photograph taken in what one supposes must have been the same session, to judge from the way the light

falls. There is the same rather squalid location—a scored and soiled wall stands behind a metal fire escape. Jim, bare chested, squats beside the ladder, his hands on its rungs, peering through his eye slits in the direction in which Tom is to be seen in the triptych. He is bathed in sunlight, and crossed with shadows cast by the ladder. The space in which he crouches looks like an air shaft. Jim is a figure of mysterious violence, but the true mystery of the photograph is that, consistent with the implicit dangerousness of the man, it is quite beautiful.

The same set of lights and shadows is in *Jim and Tom, Sausalito*. Tom has turned his head and opened his mouth to receive Jim's urine. Experts for the defense in the Cincinnati trial, asked what they saw when shown the photograph, refused to say more about this particular work than that it was "a figure study." I suppose the experts were sincere, and that they really could see, hard as this is to believe, only what their "free project" revealed to them. Their vision of the work virtually erased the content, just as the vision of right-wing critics in Congress erased what the experts saw. The jurors were clearly, and I suppose happily, convinced by the experts, but at a price. If those art experts could not see what anyone with eyes open could not fail to see, then the jurors had to conclude that they themselves had no idea at all of how to look at art. In this, I think, the formalism of the experts rendered a great

disservice, even if it got the museum and its director off the hook. And it could have played into the hands of the legislators: since the Endowment exists for the spiritual enhancement of plain men and women, of the sort the jury members represented in the trial, and if they have no idea of how to look at art, even how to describe what is clearly the content of a photograph, then why should the Endowment be continued? What reasons have the ordinary taxpayer for supporting what only experts understand?

In truth, neither the legislators nor the experts understood how to look at art, and certainly not at this art. Mapplethorpe cannot have made this handsome triplet of plates, handsomely framed, in order that viewers disregard what is shown. To deny it would be like denying the wounds in Grünewald's depiction of Christ, and to focus merely on the way the crucified figure divides the space of the panel in some dynamic way. Nevertheless, the work is not a simple disjunction of content and form, and Mapplethorpe understood this perfectly. When an interviewer drew the familiar contrast between pornography and "redeeming social value" (which was the catchphrase used often to defeat the claim that something was pornography), Mapplethorpe said, "I think it could be pornography and still have redeeming social value. It can be both, which is my whole point in doing it—to have all the elements of pornography and yet have a structure of lighting that makes it go beyond what

it is."[21] What is required further in Hegelian terms is transcendence. "Transcendence" is in fact a term in Mapplethorpe's vocabulary, though he of course had no training in philosophy that I know of. His works, he says in the *Splash* interview, "sort of transcend the problem that was solved."[22] There might, I suppose, be beautifully composed pornography that does not attain the level of transcendence. That his does, or does on occasion, is what makes him the remarkable artist he was.

Let us address the transcendental dimension of his work. One might think, after all, of a candid shot of Jim and Tom in the act, or a snapshot taken by someone bent on recording it, and contrast such an image with the triple image Mapplethorpe in fact produced. What he did, almost inconceivably, was confer a certain radiance on the act and even the tawdry place where it happens, which is touched by light, as in a baroque painting where light enters the cell window as a message of hope for the prisoner within. Tom's posture, in fact, is reminiscent of a theme widely used in baroque art, that of "Roman Charity," where a daughter makes a gift of her breast to her shackled father in order that he not starve. Undoubtedly, the Roman Charity paintings subserved prurient interests inasmuch as they allowed, under the guise of filial devotion, the artist to show and the viewer to admire a pretty breast: there was a moral overlay on a piece of lubricity, which is the inverse of our ex-

perience with *Jim and Tom, Sausalito*. Still, it was a depiction of a generous act, an act of devotion, whatever else complicates the viewer's experience, and in some way Jim here confers a benefit on Tom, although most people would have a hard time appreciating that fully or not being disgusted by it. Urinating in someone's mouth could be an act of terrible degradation, a way of demonstrating contempt, emblemizing our power and their helplessness. And no doubt something like this figures in Tom's mentality, which somehow eroticizes humiliation. At the same time, his trust in Jim and in the artist, who was also there, has enabled him to lower his guard. The two execute this strange and morally difficult ritual. The photograph accepts the dark truth of their deflected passion, and celebrates it. The ladder can be a symbol of ascent, the light a symbol of grace. The image retains its identity, and yet is brought up into the plane of art. Even the fact that it is made into a triptych carries a spiritual connotation: it was after all a form evolved for altarpieces.

My feeling is that Mapplethorpe's Catholicism affects the sense of transcendence carried by this image. To be Catholic is to have long since internalized a sense in which the flesh, while remaining flesh, is also spirit; the sense in which it is possible for a man, all the while remaining vulnerably human, to be divine. Various commentators have spoken of Mapplethorpe's Catholicism in relation to his feeling for symmetry, or his propensity to

arrange things in space as if making so many altars. And he himself spoke of this as a residue of his religious education, though he didn't remain much of a believer. But there is nothing especially Catholic in altar-building, or in symmetry: the great effigies of the Buddha are often symmetrically arranged about a vertical axis. What is finally Catholic is the abiding mystery of spirit and flesh, which has its analogies in the philosophical structure of art. The redemptive task of the art is not to make, as it were, surplus beauty, but to beautify what is initially as remote from beauty as the emissions of the flesh often are. Once, in a debate with someone who found this whole side of Mapplethorpe morally indefensible, I cited the line Yeats puts in the voice of Crazy Jane: "Love has pitched his mansion in the place of excrement." "Hardly Yeats's finest line," he retorted, and I challenged him to cite a finer. Mapplethorpe himself said, "People get blocked about what pleasure is. It can be incredibly sensual to, say, piss into someone's mouth. It can be incredibly sensual to receive it. It's all about reaching a certain mental place that's very sophisticated. It's almost impossible to talk about in clear terms." Then he said, I think profoundly, "I don't think anyone understands sexuality. What's it about? It's about an unknown, which is why it's so exciting."[23] And that is what is communicated in *Jim and Tom, Sausalito*. It is a very mysterious image. So we can talk about the content,

but only by leaving out the beauty of the photograph is it *merely* a picture of two men doing what most of us find fairly repellent. And we can talk about the beauty of the photograph, but if we leave out the mysteriousness conferred by it on the act it clearly shows, we are not accounting for the transcendence. Any work, but especially a work with so awkward a content, has to be addressed on all three levels.

No one may, as Mapplethorpe rightly said, understand sex, but it is plain that there is a high degree of imagination in the human practice of it, and of fantasy, which makes the actual physical aspect of sex merely the untransfigured component of the act we share with the other animals. What is remarkable is that images can trigger in us the same sort of excitement that pheromones trigger in insects. And some explanation is needed as to why there are individuals who can be excited by fantasies but who are in fact turned off by the actual presence of the fantasized object. I have just sketched a rather exalted interpretation, not so much of the practice of a fairly kinky form of sex as of its representation in images and indeed in art. But both the practice and the artistic representation share an element of fantasy, and even of pretense and of superstitious magic. What sort of person is Jim when not wearing his mask? Putting on the mask transformed him not so much into a monster as into someone his partner could relate to as fright-

94

Frank Diaz, 1979

ening. There has to be a play of imagination in the transactions between the Jims and Toms of the leather world. A woman who wears for her lover's benefit black lace lingerie is declaring how she wants to be thought about and responded to in moments of intimacy. We communicate through our costumes, as much through black lace as black leather, as much through jockstraps as through flannel nighties.

But the photograph carries this play of imagination onto yet another level. Mapplethorpe's oeuvre is filled with symbols of violence. There can be few images more violent in feeling than that of Frank Diaz, holding a knife in his heavily tattooed and muscular arm. It is threatening, but in a very abstract way, for he brandishes the knife without a visible target. He is an emblem of his own violent nature and at the same time a negation of it, since no one is there to be stabbed or cut. But it is Mapplethorpe himself who affects a mood of violence in much the same way Jim does when he dons his sex mask. Mapplethorpe is claiming something with his photographs of knives and guns and even of himself cradling a machine gun in a pose that recalls that of Patty Hearst. One cannot help but feel that there is a playing with the edge here as well. We find ourselves drawn to the images as art and repelled by their content, and a complex and nearly sexual connection thus exists in the space between the eye of the viewer and the photograph, a kind of mischievous

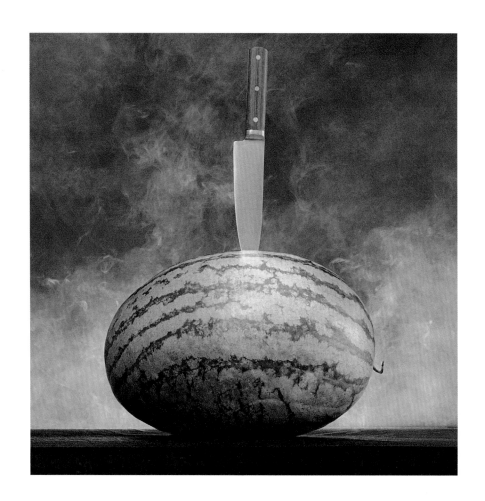

Watermelon with Knife, 1985

game. For one well-known image, Mapplethorpe stuck a dagger into a watermelon. It is, one might say, after all only a watermelon with a knife in it. But there is something menacing about it also. The watermelon looks almost comically dead.

It is hard to know how large a proportion of the gay population actually engaged in or were even particularly excited by the fantasies embodied in S&M practices. No doubt there was some continuity between mainstream homosexuality and its exaggerations in S&M: a certain fetishization of the masculine body and especially of the penis, in both cases a semiotic effort to purge from the image of the homosexual male the connotations of effeminacy, of limp-wristedness, that stereotyped the "fairy" in straight consciousness. So the leather look, the peaked cap, the flaunted biceps, the swollen crotch belong to the language of display in the same way that the furled tail feather of the peacock does, as pieces in a strategy of attractiveness and self-definition. And these have as their correlative bodybuilding. Perhaps the ability to endure pain in S&M activity itself became a sign of male fortitude. In any case, the S&M contingent, which came out of the closet as an inevitable consequence of the emergence into public light of large numbers of gays in the late sixties and seventies, presented the same kind of problem for the gay movement that

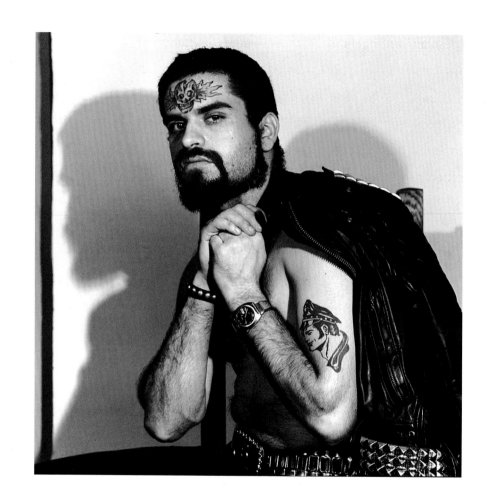

Nick Biens, 1977

the lesbian contingent did for the women's liberation movement of that era. Many feminists of the time, who thought in terms of autonomy, of equal rights and equal pay, day care, maternity leaves, benefits, power, and dignity, did not especially want also to deal with the special rights demanded by lesbians. The fear was that the image, or stereotype, of the lesbian would make it easier for men to dismiss the women's movement and harder for women who did not care to be associated with homosexuality to join it. Similarly, the stigma carried by S&M practices caused mainstream gay spokesmen to distance themselves from the play of masks, hoods, chains, and whips. It is one thing to talk about the liberty of consenting adults to follow their sexual bent, and another to come straight out and endorse something as spectacularly Grand Guignol as S&M.

Mapplethorpe's photographs were in consequence not especially accepted by the gay community, and many critics in the gay press were, somewhat to Mapplethorpe's dismay, especially harsh. Certainly the photographs were not accepted at first by the straight art world, for all its proclaimed liberality. America had undergone an immense loosening up of sexual mores, but art was still somewhat sacred and artists themselves self-appointed priests and shamans and prophets. Images such as Mapplethorpe's had to appear as profanations. After all, the American museum in

the sixties maintained the temple as the metaphor for housing art. An atmosphere of hushed reverence was standard in museums until Thomas Hoving, when he was director of the Metropolitan Museum in New York, sought to bring in a more boisterous audience than had heretofore been expected. Inasmuch as most Americans' experience with art took place in sanctums of beauty, art was regarded as something at least at the boundary of the holy, as close to actual holiness as mere secular things may attain. It must have been this sacral dimension of art that defined the atmosphere in which a National Endowment for the Arts first suggested itself as an institutional possibility. Mapplethorpe's images were flagrantly in violation of that aesthetic—and the liberation of art, whatever the art world's rhetoric, lagged behind the liberation of sexual conduct.

So neither the straight nor the gay critical press was altogether ready for playing with the edge. And in the gay press it is, I think, understandable why. Politically, because America is a conservative society, it was imperative for gays to present as conservative an image of themselves as they could, to show that in all matters other than sexual preference, gays were little different from the rest of the citizenry. Even as late as 1988, so far as the straight press was concerned, no one would have known what sorts of images were to be encountered in the corner gallery of the Whitney Museum.

Ironically, Mapplethorpe made a point, in various interviews, of explaining the readiness of certain galleries to show his work as due to their support by governmental funds.

> In California . . . I got the curator at Berkeley interested in my sex pictures and he helped me to find one of these free spaces, Langton Street, which exist through the National Endowment for the Arts, they don't have restrictions. . . . I have also had two simultaneous shows here in New York, one was portraits at the Holly Solomon Gallery, Downtown, and the other sex pictures at The Kitchen, a non-profit organization. It is in part government.[24]

This was in an interview Mapplethorpe granted Inge Bondi in 1979, and in retrospect there is an almost touching confidence in the belief he expresses that the government is there to support art that is too difficult for commercial galleries to handle. He calls these government-supported galleries "free spaces," and the moral distance traversed between 1979 and 1989, when the Corcoran show was canceled, is an index of how the lines, earlier so fluid and open, hardened on the Endowment's part. The question that was frequently asked in the early nineties, as to whether Mapplethorpe's kind of art should be subsidized at taxpayer expense, would probably have been answered af-

firmatively in 1979. It was the task of the government to support free artistic expression that could not otherwise find its outlet, just as it was the role of government to support research too expensive for private enterprise. In 1989 the answer, put by those who asked the question rhetorically, was supposed automatically to be negative.

It is hard to avoid thinking that the hardening of the lines in art did not reflect the hardening of lines elsewhere in the nation, and that the explanation has something to do with what was all but unknown in 1979: AIDS, which was indissolubly associated with male homosexuality. Homophobia became not merely fear of the sexual Other but also fear for oneself, with the homosexual the bearer of a terrifying illness. Against this scary epidemic, the issue of liberation seemed decidedly secondary, and the wider toleration of S&M practice questionable. One of the things that makes Mapplethorpe so allegorical a figure of his times is that he died of the very disease that explains to an extent the increasingly hostile resistance to his art. But at the same time it gave his art such prominence that his name has become virtually a household word: he is, along with Andy Warhol, one of the few artists whose renown has spread beyond the perimeters of the art world, and on whose art people remote from the concerns of the art world are inclined to have opinions.

The consequences of the notoriety were predictable: the show canceled by the Corcoran was thronged in its various venues, bringing in people who

didn't usually enter museums. There must have been some degree of prurient curiosity, but in the main people voted with their feet for freedom of expression. After all, whatever the truth about AIDS, the sexual revolution had spread too far and stained the public consciousness too deeply for Americans to be disposed to heed a paternalistic government telling them what they could and could not see. The sex shop is not quite as standard as the supermarket in shopping malls, but it is not that uncommon either; and the term "adult" has come to connote not so much emotional maturity as someone with a recreational interest in XXX videos, water beds, vibrators, frilly lingerie, and the ideal of simultaneous orgasm. Condoms are now distributed to high school students, and safe-sex videos that are visually indistinguishable from soft-core pornography are beamed out over television channels. S&M practices were discussed in widely used texts like *The Joy of Sex*, and He and She—or She and She or He and He—were encouraged to experiment, where both partners were willing and no one got hurt and there was an agreement to desist when asked to.

No less important than these transformations was the fact that art had come more and more to be regarded as something to which Americans everywhere had a civil right: every city in the country had some sort of an art world, with local artists and collectors, and a broader and broader public for traveling shows brought in by increasingly professionalized curators. The

threats to the Endowment were a threat to all these aspects of what had come to be perceived as a Good Life, in which art institutions played a central role. And what audiences discovered in the installations of Mapplethorpe's photographs was something that surprised them, namely, beauty, a quality of art that had once been thought central to distinguishing it from craft—what the beaux arts had in common. Beauty was something in extremely short supply in the standard art productions of the 1980s.

It was beauty that defined Mapplethorpe's work, and that made it somewhat suspect in the eyes of the art world, where beauty had come to seem inconsistent with the urgency or the sincerity of the neoexpressionist work that typified the art of the eighties. Art-world professionals, whether concerned with photography or something else, essentially endorsed the sort of aesthetic discussed in connection with Winogrand's work—an aesthetic in which accident was assigned a role altogether at odds with the firm imposition of artistic will central to Mapplethorpe's compositions. Moreover, in the late eighties the ideal of *quality*—which one could almost illustrate by means of one of Mapplethorpe's flower studies or nudes—was enduring a kind of political critique. It was almost as if "quality" were itself a form of oppression. Those who might, under the auspices of multiculturalism, express themselves differently (women, or Latinos, or blacks, or Native

Americans, or Chinese, or Japanese-Americans) were felt to have their own distinct "language of forms" that had little to do with the formalistic structures Mapplethorpe associated with "art." In that atmosphere, highly and angrily politicized, perhaps all that preserved Mapplethorpe's reputation was the knowledge that he had been *gay*, and hence suitably marginalized. The second irony of the attacks by Jesse Helms and the religious right was that art worlders took a second look. Many of those who had consigned Mapplethorpe to the ranks of the *pompier* felt under moral pressure from his posthumous martyrdom to believe that the work must be deeper than they had thought, and finally more serious.

Even so, the ideal of beauty central to Mapplethorpe's photographs was still at odds with the atmosphere of moralized aesthetics of the late eighties and nineties. Mapplethorpe acknowledged that perfection was an aim of his, and that "in fact, I am obsessed with beauty. I want everything to be perfect."[25] This is evident, for example, in his treatment of penises. He has been credited, by the poet and critic Richard Howard in particular, with having "aestheticized the phallus."[26] Whether or not this is true, Mapplethorpe in fact did, in picture after picture, present the viewer with exceptionally large penises, and it seems a fair inference that his own sexual fixations had to have centered around the big, and preferably black, penis. Aestheticization, after

105

all, can take many forms. Instead of the megapricks fancied by Mapplethorpe, small ones, as in ancient statuary, where even the muscular and meaty Hercules is shown with a boy's penis, could have been mandated. A *New Yorker* writer, describing her experiences in teaching classical literature in Malawi, reported an episode in which she showed her students photographs of statuary from antiquity. One of the female students asked, "in a clear, ringing, and faintly derisory voice, why all the male statues had such small penises—a question that prompted every African male to lean forward in his chair and grin enormously, and every European male to sit up a little straighter." The teacher mumbled something about the "idealization of the human form," but the episode is interesting because it underlines the degree to which a small elegant penis is as much an aestheticization of the organ as a thick and long one.[27] For that matter, even a photograph that blurs the penis can be said to aestheticize it, since blurry photographs were felt at one time to be arty, and more like paintings. In the ancient world, heavy penises were regarded as comical, and the leather dildo was the emblem of prancing satyrs on stages. It is not clear that the heavy penis in Mapplethorpe's photographs is any less comical: the photograph may be beautiful without the penis rendered in it becoming derivatively beautiful. In a way, the stubbornly and irrepressibly comic emblem of the large penis works as the explicitly pornographic images

do: the folkloric nature of the organ cannot quite be negated or transcended by the beauty of the photograph.

I incline to the view that the humor Mapplethorpe claims to have expressed in his photographs is finally present in those ponderous phalluses, and it is instructive to examine two images from this perspective, both quite well known and one perhaps Mapplethorpe's masterpiece—the legendary *Man in Polyester Suit* of 1980 and *Mark Stevens (Mr. 10½)* of 1976. In both photographs the owner of the penis is shown as headless. In the case of *Man in Polyester Suit*, Mapplethorpe recalled that "he did not want his portrait to be taken in relationship to his cock. There are no pictures I have ever taken of this person that show his face and his genitals in the same picture. He did not want to be associated with an enormous tool. I promised him I would never photograph him as a whole or name him."[28] Indeed, this is one of the relatively rare photographs that does not have the subject's name in the title. Mark Stevens, by contrast, though headless, is named, and it would seem that his identity is caught up with the identity of his organ. He is apparently proud of what the man in the polyester suit is dubious about.

The image shows Mark Stevens bent over his pride and joy, almost protectively, for his torso and the back of his arm (tattooed with a little devil) form, with the linen platform on which his penis is stretched out, a sort of

108

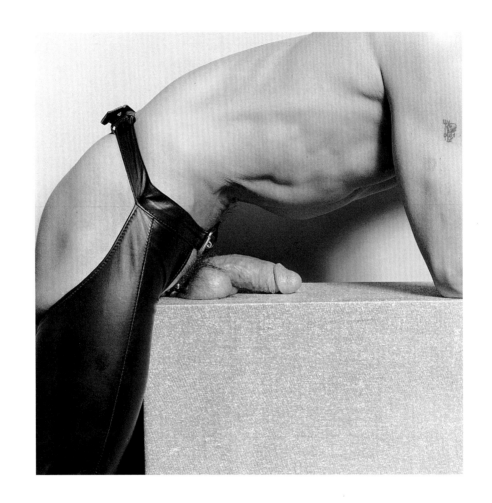

Mark Stevens (Mr. 10½), 1976

container or casket, as if to house a jewel. He wears leather chaps, open back and front to facilitate access to his sexual parts. Two congruent triangles are formed by the shadows, one behind his arm, one in front of his leg, that point, like arrows, at the astonishing organ. A shadow has been cast behind the penis itself to make it that much more salient. The photograph in fact belongs to a genre that glamorizes objects like jewelry, and the artful deployment of light and shadow carries the rhetoric of something being shown that is rare and priceless. (There is a well-known painting in Pompeii with the figure of a man who has placed his penis in the pan of a scale: the picture bears the legend "Worth its weight in gold.") The image is meant to enhance the desirability of the organ, and the style and the content of the photograph work together to form a visual equivalent to the expression "putting something on a pedestal." It comes dangerously close to a sort of joke, or perhaps it is a joke, and demonstrates how resistant the phallus is after all to beautification: it carries too many associations for that.

The case of *Man in Polyester Suit* is more complex, just because it is far less obviously a visual pun, and because it is a work of exceptional beauty, a kind of harmony of grays. There is a marvelous interplay between fabric and skin. The huge penis hangs, sullen and heavy, like the trunk of an elephant, out from the subject's unzipped fly and between the edges of his jacket,

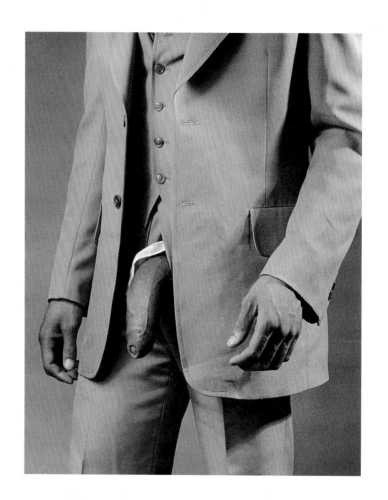

Man in Polyester Suit, 1980

which is parted like a curtain. It is perhaps the exemplary Mapplethorpian photograph in part because the penis is not completely aestheticized but, if it does not sound absurdly redundant to say this, also eroticized. And it dramatizes the degree to which in art the penis has, for the most part, merely been an identifying attribute of the male gender as breasts are the attribute of the female gender. But *Man in Polyester Suit* puts the viewer on edge by aestheticizing the photograph while leaving the penis the difficult and dangerous thing it is. There would be something absurd in talking about this photograph merely in terms of the silvery grays, the whites, the blacks, the lights, the shadows, the textures—or in terms of the figure's stance—in the voice of one of the experts at the Cincinnati trial. It is as important to the intended response that the fabric be acknowledged as polyester, with all the social and economic connotations of that fact, as that the penis be unredeemed by the beauty its color contributes. So it has to be confronted for what it is, veined and pulpy, rather than (merely) a component in a felicitous design. Even the cropping, quite apart from the subject's reported diffidence in having his name disclosed or face shown, carries an extra meaning here. Cut off at the knees and at the neck, the figure is like a fragment of what had once been some fierce divinity. There is beauty, and there is transcendence, but the sexual truth is preserved

and cannot be repressed. The photograph demonstrates what "playing with the edge" means. Unless there should be some unimaginable transformation in sexual attitudes, it will always keep the viewer suspended between beauty and danger. It is *supposed* to be shocking. When morality changes so that it is no longer shocking, Mapplethorpe's intentions will fall away into incomprehensibility.

Mapplethorpe said that there is no difference to speak of between photographing a cock and anything else, which is true and at the same time a kind of self-deception. The way in which it is true is a mark of how Mapplethorpe was distinctive among photographers:

> That's just the way I approach things. The way I approach art in general. I take it as it is. I don't come to it with prejudice. It's like when I photograph celebrities. . . . I don't have this pedestal notion that I think a lot of photographers have when they photograph celebrities. . . . I often don't know who these people are. It's not that important to me and I think it is a great advantage to approach things that way. I think it's given me access to a lot of people because I'm not in awe of anybody and I never have been. I'm just not the kind of person who has heroes. I never had heroes.[29]

112

He was aware that his refusal to draw any particular distinction between his commercial work and what he did as "art" distinguished him from other photographers.

> I think the interesting thing about Penn and Avedon is that they started in commercial photography and then got into "art" and they separated the two. Their art as opposed to their work.[30]

In another interview, he added that he did not think this a healthy approach:

> Penn thought he had to smash cigarette butts and beer cans and take those grungy, dirty street pictures. He thought that that was one way to make art. He does such beautiful still lifes, he could have just done them without a product in them and I'm sure they would have been beautiful. I think Avedon did the same when he went to the Diane Arbus school of photography to make his art, when in fact his best pictures are his incredible fashion pictures, the ones with elephants, etc. The picture of the elephants is so together and elegant, I think that's his art.[31]

Asked what he thought of Avedon's "In the American West" series, Mapplethorpe said, "I don't think he enjoyed sitting around and talking to those people in those pictures. They are pictures of white trash, and Avedon's just

the opposite."[32] Mapplethorpe may have been deceiving himself, but it was his belief that he formed enough of a bond between his subjects and himself that a personal relationship between them was possible outside the photographic situation. There can be no question but that he was driven by considerations of money, and that this tended to determine whom he portrayed, but in the main, one feels that he is genuine in his attitude toward his subjects, and there must therefore have been subjects he would not have taken on—"white trash," for example. *Within* the limits his personality defined, he was almost radically egalitarian.

114

But there is a clear sense in which he was deceiving himself in saying that photographing cocks is like photographing anything else—flowers, say. "My approach to photographing a flower is not much different than photographing a cock," he told Gerrit Henry. "Basically it's the same thing. It's about lighting and composition. It doesn't make much difference. It's the same vision." Janet Kardon said, one feels a trifle uncomfortably, "I think you treat the flowers like the cocks and the cocks like the flowers," and Mapplethorpe responded, "Yes, I think they're the same."[33] But cocks were the center and focus of Mapplethorpe's universe. He was, one feels, a worshiper. And the self-deception comes with the claim that it's all a matter of lighting and composition when in truth for him it was also a matter of excitement and danger.

The lighting and composition are for the beauty of the work, the danger and excitement for the power, which for him came from cocks or anything else that could be treated as a cock. Of his flower pictures, he said that "some of them have a certain sinister side to them, I think. A certain edge, a creepy quality. . . . I think there is some weirdness to my pictures of flowers."[34] A passage in his discussion with Janet Kardon is particularly instructive:

> *RM:* I think that the flowers have a certain—
>
> *JK:* Are sexy?
>
> *RM:* Not sexy, but weird. I don't want to use the word "weird," but they don't look like anyone else's flowers. They have a certain archness to them, a certain edge that flowers generally do not have.
>
> *JK:* Do you think they're threatening?
>
> *RM:* That's not the exact word. But they're not fun flowers.
>
> *JK:* No, they're not.
>
> *RM:* I don't know how to describe them, but I don't think they're very different from body parts.[35]

When Mapplethorpe employs the term "body part," it is pretty clear that what he has in mind is the penis. In discussing the Man in Polyester Suit's

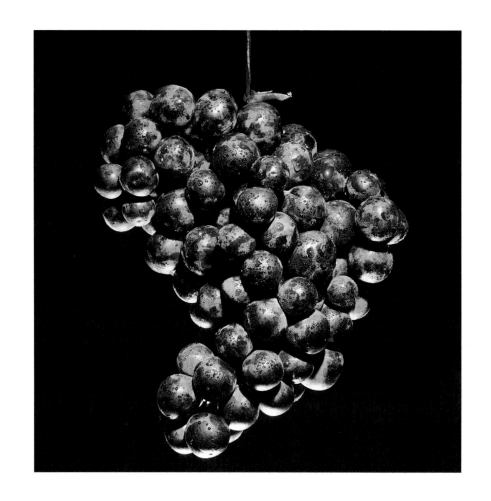

Grapes, 1985

qualms about having his identity revealed, the artist confessed that "if I had a great body part I would want that body part identified when it was published as me."[36] So if there is some parity of affect between flower and penis, it is from the direction of the latter that the aura is conferred, not necessarily in terms of parity of shape and feeling but of *edge,* to use that focal term of Mapplethorpian aesthetics. There are plenty of images of elongated objects—an eggplant, a fish spread out on newspaper—that have a formal kinship to the phallus, and there is a beautiful bunch of grapes suspended and hence "hung" the way the man in the polyester suit is. But the real connection is less obvious and more a matter of that primordial feeling experienced when, as a youth, Mapplethorpe encountered those pornographic pictures on Forty-second Street. His flowers transmit a feeling like that to us, which is what makes them unique. Flowers have been represented since the beginnings of still life as a genre and, like the female nude, they have come to carry the atmosphere of the art-school studio. It is almost miraculous that an artist could generate so much visual excitement from so worn a motif as a bunch of flowers. They are natural subjects for a photographer whose interest is beauty, but the beauty of Mapplethorpe's flowers is not that of Wordsworth's daffodils. It is the beauty characterized by Rilke in the First Duino Elegy as the "beginning of terror we're still just

117

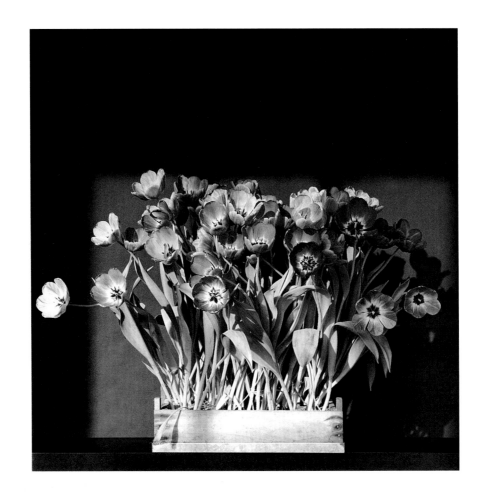

Tulips, 1983

able to bear, / and why we adore it so is because it serenely / disdains to destroy us."[37] Mapplethorpian beauty is a compound of elegance and menace, as in a finely balanced sword or an ornamental dagger. It has little to do with pleasure. In fact, it is the kind of beauty whose objective correlative is that dangerous sort of sex he chose to portray.

The dialogue with Janet Kardon is instructive because of the incapacity of either speaker to capture in words what is expressed in Mapplethorpe's flowers. He elicits from flowers some kind of meaning we would never have suspected was there. Everyone recognizes baby's breath. It is among the commonplace flowers, like the daisy or the rose. The very name connotes tininess, innocence, sweetness. What one isn't prepared for is baby's breath that radiates a kind of blind aggressiveness, incandescent, tangled, but sharp, as if at the moment of death when it is said that we see everything with absolute clarity. Each twiglet and little bud stands out against a black background, and awakens a faint reflection in the table that would, without the reflection, disappear into the enveloping blackness. To my mind the masterpiece among the flower masterpieces is the box of tulips of 1983, where the wooden container is placed in the center of the square format, but with its bottom edge nearly coincident with the bottom edge of the frame. It is like a coffin, out of which the flowers writhe upward, like flames or souls, while the back-

119

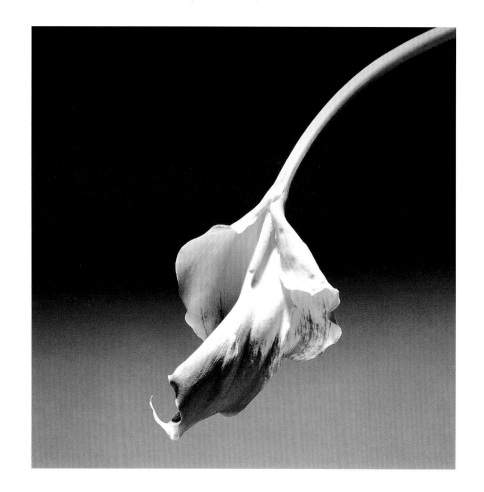

Calla Lily, 1986

ground is divided by some shadow of mysterious provenance into three vertical rectangles, like a view of nothingness through the bars of a prison. In another, a single calla lily, half furled, enters the space of the photograph like the head of some monster with a thin neck, curving down from the precise upper right corner, as if to feed. Its mandible-like blossom seeks blindly for prey. And the light with which it is irradiated gives it a mythic presence, especially against the evocative background, divided into dark and light gray bands.

Given the syllogism that connects "body parts" with flowers, it becomes clear why Mapplethorpe felt that, in the photographic moment, "the creative impulse is not there" with women. "Photographing women is not the experience I am seeking," he said. "It's like with pictures of kids. I think my pictures of kids are good and interesting, but I don't do many of them."[38] The reason, as I see it, is that women were never felt by him to be as exciting as men were, with perhaps the exception of Lisa Lyon, a woman who played with the edge of femininity and implicit androgyny. Lyon was the first World Women's Bodybuilding Champion. It was as if she sought to bring herself to the edge that partitions the sexes without altogether crossing it. Female bodybuilding has come a long way since Lisa Lyon, and, what with the use of steroids, there are women whose female attributes seem relics of a prior

Lisa Lyon, 1980

existence. Lyon, by contrast, is startlingly feminine in Mapplethorpe's photographs, and it is difficult for us to see her masculinity. Mapplethorpe photographed her in certain costumes that were perhaps meant to put her masculine identity into relief—lacy lingerie, bridal veil, and so on—but these seem to have the reverse effect of that intended.

The other woman who must be an exception to his disclaimer is Patti Smith, the first love, the true love, with whom Mapplethorpe shared his first apartment in Manhattan, at the Chelsea Hotel. Characteristically, he always described her as possessing a certain "magic," a term he restricted otherwise to sex and to art, and there is to that degree an edge to the images he made of her. But there is no sense of danger or of threat emanating from her. In one famous image she is shown nude and squatting at the far left edge of an empty room, holding for support onto an elaborate radiator. She looks like a prisoner, immensely vulnerable and yet transcendent, staring out, not with defiance at the viewer, but with a manic self-assurance, as if she were beyond harm. Toward Patti Smith, Mapplethorpe is unfailingly protective: in an early polyptych, with five panels, she is shown in a white shirt, against a wall, facing a central panel that reads DON'T TOUCH HERE. In each of the lateral pairs she seems to be shy, uncertain, virginal, apprehensive, questioning—and DON'T TOUCH HERE is a warning to keep one's hands off. The only other

123

124

Hermes, 1988

© 1988 THE ESTATE OF ROBERT MAPPLETHORPE

photograph that shows that order of female fragility is a portrait of himself as a coltish girl with makeup on.

For me, oddly, the least moving images of his repertoire are the male nudes, which seem like ornaments, faintly Art Deco. Mapplethorpe intended at one point to be a jeweler—an ambition he gave up because jewelry seemed to him finally insufficiently important, as indeed it is in the art world in which he hoped to make his name. Moreover, there is no evidence that he had the sort of gift that would have made him significant as a jewelry designer. His early forays into sculpture were fetishistic to an almost embarrassing degree, and his reputation could have only been enhanced had all those mounted Jockey briefs and body shirts been destroyed. He prided himself on some furniture designs that he executed late in his life, but the table in which he took such pride seems merely tasteful. I feel, perhaps wrongly, that the male nudes, formed into ornamental poses, placed on pedestals, treated abstractly and in a way sculpturally, are again simply tasteful; and though he never made a bad photograph, the statuary male nudes, when not eroticized, lose the dark power of his greatest work. Greater than them by far are the very late photographs of sculpture. There is a Hermes of 1988 which is so intensely illuminated that it is almost stripped of shadow and turned into a piece of absolute luminescence. Placed against a black drop, this becomes a being

metamorphosed by the magic of photography from stone to light, and from light to life. The features are barely discernible in the blaze of white, and the Hermes has very nearly the quality of a religious declaration. My own view is that these late images, made when he was terribly ill, responding to heads and marble figures brought him by Dimitri Levas, are among his greatest. There is something extraordinarily moving in the thought that he made them when he was too sick to do much else, and with the certain intuition of impending death. It is almost as if the god Hermes had come to fetch him.

What gives a certain authority to Mapplethorpe's art is that virtually everything he ever did was there at the beginning: the self-portraits, the shots of Patti Smith, the sad pornography, the flowers. He began as he ended. His life has the unity that consists in working out a vision from which he never wavered.

ROBERT MAPPLETHORPE

"Fifteen years' worth of Robert Mapplethorpe's prints are represented in a show of nudes, portraits, and still-lifes," is how the Whitney Museum's show (through October 23 in New York City) of this dark and swanky photographer is identified in the bright idiom of the *New Yorker*'s "Goings on About Town."[1] How nice! someone in Tarrytown or Katonah might think, having seen this artist's elegant digs written up in *House & Garden:* Let's make a day of it—shop Madison, have lunch somewhere, and then see the nudes, portraits, and still lifes. Just the thing! And sure enough, the first of three photographs to one's right just before entering the show is a portrait of the late Louise Nevelson. And right next to that is a nude and a portrait at once, since its title is *Carleton.* Carleton is shown from behind, his head bent away from

Reprinted from *The Nation*, 26 September 1988.

us into the Caravaggian black of the background, thrusting his buttocks forward, which are then pulled slightly apart by his legs, which hang on either side of the table on which he is posed, leaving a triangle at their parting as the focus of the print, as black as the abstract blackness of the background. And next to this is something we soon make out to be a male nipple, a vortex in a network of pores and follicles, skin as it would have been seen by the microscopic eyes of Gulliver on the Brobdinagian ladies who liked to dandle him. Seen close up, this erotically charged locus of human skin contrasts with the beauty of that which stretches, smoothly and warmly, over the marvelous muscles of the male nude, placed between the dead artist and the leathery button of flesh. Is *Nipple* to be classed as a nude? Or a still life? Or a synecdochical portrait of sorts (you will encounter a double image, two stages of a cock and balls, a portrait by the same criterion as *Carleton*, since titled *Richard*). The question of genre will haunt the visitor as he or she works through the exhibition, since the still lifes more and more seem metaphors for displayed sexual parts, which are often the main attribute of nude and seminude portraits. But that question will soon be stifled by others more haunting still.

The three prefatory photographs are high-style, high-glamour studies, reminiscent of an Art Deco sensibility, embodying an aesthetic that Map-

plethorpe attained early and steadily maintained: some of the portraits look as though they belong in the stateroom of a suave ocean liner, in a mirrored frame, beside the chromium cocktail shaker and an artful arrangement of stark flowers of just the sort shown in Mapplethorpe's still lifes. They are elegant, luxurious, sophisticated, impeccable. But they are far more than that. The linking of death and art in the famous sepulchral head of the aged sculptor, the delibidinization of the erogenous in the magnified and distanced nipple, are held together, in one of the great moral syllogisms of our age, through the perfect male nude, viewed from the rear—from its vulnerable side—as middle term. This memento mori would not have been there at the beginning of Mapplethorpe's project, in which the high style of the 1930s was appropriated to register a subject matter of the 1970s, when this artist undertook to treat, from the perspective of serious art, the values and practices of the sadomasochistic subculture of homosexuals who were into bondage and domination. But it has certainly cast its retrospective shadow over this body of work since 1981, when AIDS was first announced, and the active male homosexual found to be in a population at high risk. A show of Mapplethorpe is always timely because of his rare gifts as an artist. But circumstances have made such a show timely in another dimension of moral reality, and I am

grateful the organizers did not stint on the gamy images of the 1970s, for they raise some of the hardest questions, and comprise Mapplethorpe's most singular achievement.

Consider *Mark Stevens (Mr. 10½)* of 1976. Mark Stevens is shown in profile, his powerful body arched over his spectacular penis (Mr. 10½?), which he displays laid out but unengorged along the top of a linen-covered box, on which he also leans his elbow. The picture is wider than it is high, by a ratio of 5 to 4, almost forcing Mark Stevens to bend over, despite which the space is too small to contain him: he is cropped at the shoulder, so we do not see his head, as well as at the knee, and along the back of the leg and the front of the bicep. Little matter: the one anatomical feature that is shown integrally is doubtless where Mark Stevens's identity lay in 1975, and his stomach is held in to give that even greater amplitude. Mark Stevens is wearing a black leather garment, cut away to expose his buttocks and his genitals, something like the tights affected by the sports at Roissy, where "O" underwent her sweetly recounted martyrdoms. And there is a tiny tatoo on his arm, of a devil with a pitchfork and flèched tail, connoting a playful meanness. Formally, we may admire the interesting space bounded by elbow, box surface, belly, and chest, a sort of display case in which Mark Stevens's sex is framed as something rare and precious. Cropping, inner and outer space, calculated shadows, and con-

130

trolled blacklighting—these belong to the vocabulary of high photographic art, the sort that Weston lavished on peppers in the 1930s, or which Mapplethorpe himself devoted, in 1985, to an eggplant, also laid out on a table, echoing Mark Stevens's recumbent phallus. Still life and nude or seminude portrait interanimate one another, here and throughout the show, and as a photograph, the study of Mark Stevens, quite as the other studies of leatherclad gays, is of an artistic order altogether different from the images that must have found their way into magazines of that era devoted to pain, humiliation, and sexual subjugation, with their advertisements of sadistic gear—whips and chains and shackles, hoods and leather wear (the he-man's equivalent to sexy lingerie), and the pathetic promises of ointments and exercises designed and guaranteed to increase length, diameter, and staying power.

Nor are these photographs really in the spirit of documentation, recording a form of life, though in fact and secondarily they provide such a record. They are, rather, celebratory of their subjects, acts of artistic will driven by moral beliefs and attitudes. Mapplethorpe is not there like a disinterested, registering eye. He was a participant and a believer. In exactly the same way, Mark Stevens was not a subject but a kind of collaborator: he agreed to display himself, he chose to dress himself in those symbolic vestments, to take and hold that pose. We see him no doubt as he would have wanted to be seen, as Mr.

10½, but as he knew he would be seen by someone he could trust, because the photographer would show their form of life from within. We see him, indeed, from within a homosexual perception, and it is that perception, that vision, that is the true subject of these works. They are not just of gays at a certain moment in gay history, when it all at once seemed possible for this to become the substance of serious art. The images are flooded with a way of seeing the world, given embodiment, made objective, in a suite of stunning photographs.

Analogously to the way in which Mark Stevens's phallus is made focal by the proportions of the photograph, by the cropped figure and the interior space, so, I think, is the phallus as such made focal in the exhibition taken as a whole, and I applaud the curatorial intuition that went into the selection and installation that makes this true. Richard Howard, in an inspired catalog essay, credits Mapplethorpe with having aestheticized the genitals, drawing attention to the correspondence in form and function between these and flowers, which are "the sexual organs of plants."[2] Howard is doubtless correct, but then, it seems to me, immensity must pay an important role in this aestheticizing, and hence in the vision from within which the (male) genitals are perceived as beautiful. And this is disappointingly as reductive and mechanistic an attitude as that which thematizes big breasts in women. In *Man in*

132

Polyester Suit of 1980, the subject, in his three-piecer, again cropped at shoulder and knee, has an open fly through which an elephantine phallus hangs heavily down, shaped like a fat integral sign, a thick S of flesh. In *Thomas*, a black male presses like Samson against the sides of a square space that walls him in, and his genitals hang like fruit between his spread legs—like the contextually phallicized bunch of grapes hanging from a string in a picture of 1985. But all the nudes are, as the expression goes, well hung, and one wonders if Mapplethorpe's aestheticizing project would have allowed another choice.

In a famous episode in *A Moveable Feast*, F. Scott Fitzgerald expresses concern about the size of his penis, Zelda having said it was inadequately small; and Hemingway suggests he compare himself with what is to be found on classical statues, saying that most men would be satisfied with that. In my nearly four years as a soldier, I would have noticed it if anyone was equipped like the Man in Polyester Suit, or Mark Stevens for that matter. Robert Burns in one of his nastier verses wrote, "Nine inches doth please a lady"—but something of that dimension would have been negligible in the baths and washrooms of the 1970s if Mapplethorpe's models are typical. On the other hand, there is a wonderful portrait of Louise Bourgeois, wearing an improbably shaggy coat and grinning knowingly out at the viewer, as if to connect her, us, the artist, and his megaphallolatry in a piece of comedy—for she

carries under her arm a sculpture, I dare say hers, of a really huge phallus and balls (Mr. 36½), putting things in perspective. I was grateful to the wise old sculptor for reminding us that the huge phallus was regarded as comical in the ancient world, and there are wonderful images on the sides of Grecian vases of actors wearing falsies to crack them up at Epidaurus. Even so, phallic references define this show (study the relationship between breasts, neck, and head in the uncharacteristic portrait of Lisa Lyon, usually seen, as in a book of Mapplethorpe's photographs of her, engaged in bodybuilding).

What is interesting is less the phallocentrism of Mapplethorpe's aesthetic than the politicizing of that aesthetic, preeminently in the images from the late 1970s, to which the portrait of Mark Stevens belongs. That was a period in which gays were coming out of the closet in large numbers, defiantly and even proudly, and were actively campaigning not only to change social attitudes toward themselves but to build their own culture. It seems clear to me that these photographs were political acts, and that they would not have been made as art were it not the intention to enlist art in some more critical transformation. I am insufficiently a historian of that movement, but my hunch is that sadomasochism must have presented some of the same sorts of dilemmas for the gay liberation movement that lesbianism initially did for the women's liberation movement. So this is not, as it were, "The Joy of S&M," but an artistic

form of a moral claim on behalf of practices other gays might have found difficult to accept. Even today, it is difficult for his most avid enthusiasts to accept the 1978 self-portrait through which Mapplethorpe declares his solidarity with Mark Stevens; with the scary couple, Brian Ridley and Lyle Heeter, leather boys in their sexual uniforms, Brian seated, shackled, in a wing chair while Lyle stands possessively over his shoulder, wearing his sullen master's cap, holding Brian's chains with one hand and a fierce crop with the other; or with Joe, encased in leather from crown to sole, creeping along a bench, with some sort of tube whose function I cannot even imagine strapped to his mask. Mapplethorpe shows himself from behind. He is dressed in a sort of jerkin, and in those backless tights worn by Mark Stevens. He is looking over his shoulder at us, his Pan-like head with its small soft beard glowering a sort of defiance. He is holding the handle of a cruel bullwhip up his anus. The visual equation between the phallus and the agency of pain contributes another component to genital aesthetics.

It is possible to appreciate this self-portrait formalistically and draw attention, like a docent, to shadows of graded intensity, for the subtle play of values. In the same way it would be possible to connect Mapplethorpe's own features with the little Pan's head in *Pan Head and Flower*—and the flower itself, its pistil hanging out of the petal, with the penis in *Man in Polyester Suit*.

Anything that is art can be seen that way. You can pay particular heed to the play of hues and the strong diagonals in Titian's *The Flaying of Marsyas*, which so unsettled us all when it hung in the National Gallery not long ago. But I do not know what sort of person it would be who could look past the blood dripping into a pool from which an indifferent dog laps, or the exposed and quivering flesh, the hanging skin, the absolute agony of the satyr hung by his heels while Apollo carves away, to dwell on niceties of composition. A photograph such as Mapplethorpe's self-portrait cannot have been made or exhibited for our aesthetic delectation alone but rather to engage us morally and aesthetically. It would be known in advance that such an image would challenge, assault, insult, provoke, dismay—with the hope that in some way consciousness would be transformed. Its acceptance as art cannot be the only kind of acceptance at issue. It would have to be a pretty cool cat for whom the triptych *Jim and Tom, Sausalito* of 1978, which shows, in each of its panels, what looks like Jim pissing into Tom's eager mouth, recommends itself as a particularly good example of what gelatine silver prints look like.

A pretty rough show, then, for someone who came to see nudes, portraits, and still lifes. It is made rougher still by the inescapable dates on the labels of the stronger images, all of which come from that hopeful ignorant time when it seemed that all that was involved was a kind of liberation of attitude concerning practices between consenting adults in a society of sexual plural-

ism. Of course the show has its tenderer moments. There are prints of over-whelming tenderness of Mapplethorpe's great friend, Patti Smith. There is a lovely picture of Brice Marden's little girl. It is possible to be moved by a self-portrait of 1980, in which Mapplethorpe shows himself in women's makeup, eager and girlish and almost pubescent in the frail flatness of his/her naked upper body. There is a certain amount of avant-garde scrimshaw in the show, experiments with shaped frames, with mats and mirrors; and then finally there are a certain number of just elegant portraits, nudes, and still lifes. But the self-portrait as young girl remains in my mind as the emblem of the exhibition, and for the dark reality that has settled upon the world to which it belongs. One cannot but think back to Marcel Duchamp's self-representation in maquillage, wearing the sort of wide-brimmed hat Virginia Woolf might have worn with a hatband designed by Vanessa, with ringed fingers and a fur boa. Duchamp even took on a feminine alias, Rrose Sélavy ("Eros c'est la vie"). Nor can one help but feel saddened that Rrose Sélavy has lost her enduring innocence and changed her name to Rrose Sélamort.

The *Harper's Index* recently juxtaposed the number of deaths due to AIDS with the number due to measles. The former is insignificantly small by comparison with the latter, but numbers have little to do with it, at least not yet. With AIDS a form of life went dead, a way of thought, a form of imagination and hope. Any death is tragic and the death of children especially so, thinking

of measles now primarily as a childhood death. The statistics are doubly sad since means for prevention and treatment are available, so the deaths by measles index an economic tragedy as well. But this other death carries away a whole possible world. The afternoon I visited the Mapplethorpe exhibition, I was impressed by my fellow visitors. They were subdued and almost, I felt, stunned. There were no giggles, scarcely any whispers. It was as though everyone felt the moral weight of the issues. And one felt an almost palpable resistance to face the thoughts the show generated, which each visitor had to overcome. It is not an easy experience, but it is a crucial one. Art is more than just art, and the Whitney took on a higher responsibility in supporting this exhibition.

Look at the enigmatic self-portrait of 1986, to your right as you exit the show. It is at right angles to the triad of photographs before which we paused while about to enter the room, and whose meaning is deepened by what we have seen and thought. Here the artist is dressed in a formal way, with wing collar and butterfly bow. With his long sideburns and taut neck muscles, he looks like a tense dandy. His head is turned slightly up and to the left, and the face he shows us wears a serious, questioning look. I expect mine did as well. So, by rights, should yours.

138

NOTES

LOOKING AT ROBERT MAPPLETHORPE´S ART

. "Dr. Christina Orr-Cahall, Statements Following Resignation from the Corcoran, December, 1989," in Richard Bolton (ed.), *Culture Wars: Documents from the Recent Controversies in the Arts* (New York: The New Press, 1992).

2. Hilton Kramer, "Is Art above the Laws of Decency?" *New York Times*, 2 July 1989. In Bolton, *Cultural Wars*.

3. David Freedberg, "Joseph Kossuth and The Play of the Unmentionable," in *The Play of the Unmentionable: An Installation by Joseph Kossuth* (New York: The New Press, published in association with the Brooklyn Museum, 1992).

PLAYING WITH THE EDGE

1. John Szarkowski, *Gary Winogrand: Figments from the Real World* (New York: Museum of Modern Art, 1988).

2. Ibid.

3. Dominick Dunne, "Robert Mapplethorpe's Proud Finale," *Vanity Fair*, February 1989.

4. William Ruehlmann, "It May be Kinky but He Says It's Art," (Norfolk) *Ledger-Star* 25 January 1978.

5. Bart Everly, "Robert Mapplethorpe," *Splash*, April 1988.

6. Gerrit Henry, "Robert Mapplethorpe—Collecting Quality: An Interview," *The Print Collector's Newsletter*, September– October 1982.

7. Peter Galassi, *Pleasures and Terrors of Domestic Comfort* (Museum of Modern Art, 1991).

8. Sam Wagstaff, Essay, in *Robert Mapplethorpe: Process* (New York: Barbara Gladstone Gallery, 1984).

9. Susan Sontag, "Certain Mapplethorpes," in *Robert Mapplethorpe: Certain People: A Book of Portraits* (Pasadena, Calif.: Twelvetrees Press, 1985).

10. Barbara McKenzie, "Robert Mapplethorpe," *Open City*, November 1985.

11. Gary Indiana, "Robert Mapplethorpe," *Bomb*, Winter 1988.

12. "Dr. Christina Orr-Cahall, Statements Following Resignation from the Corcoran, December, 1989."

13. Indiana, "Robert Mapplethorpe."

14. Carol Squiers, "With Robert Mapplethorpe," *The Hamptons Newsletter*, 27 August 1981.

15. McKenzie, "Robert Mapplethorpe."

16. Ibid.

17. Mark Thompson, "Mapplethorpe," *The Advocate*, 24 July 1980.

18. Ibid.

19. Ibid.

20. Jean-Paul Sartre, *Being and Nothingness: An Essay in Phenomenological Ontology*, tr. Hazel E. Barnes (New York: Philosophical Library, 1956), pt. 4, ch. 1, III.

21. Everly, "Robert Mapplethorpe."

22. Ibid.

23. Ibid.

24. Inge Bondi, "The Yin and Yang of Robert Mapplethorpe," *Print Letter* (Switzerland), January–February 1979.

25. Henry, "Robert Mapplethorpe— Collecting Quality."

26. Richard Howard, "The Mapplethorpe Effect," in *Robert Mapplethorpe* (New York: Whitney Museum of American Art, 1988).

27. Caroline Alexander, "An Ideal State," *New Yorker*, 16 December 1991.

28. Henry, "Robert Mapplethorpe— Collecting Quality."

29. Ibid.

30. Ibid.

31. Indiana, "Robert Mapplethorpe."

32. Henry, "Robert Mapplethorpe—Collecting Quality."

33. Janet Kardon, "Robert Mapplethorpe Interview," in *Robert Mapplethorpe: The Perfect Moment* (Philadelphia: Institute of Contemporary Art, University of Pennsylvania, 1990).

34. Ibid.

35. Ibid.

36. Indiana, "Robert Mapplethorpe."

37. Rainer Maria Rilke, "The First Elegy," in *Duino Elegies*, tr. J. B. Leishman and Stephen Spender (New York: W. W. Norton, 1939).

38. Kardon, "Robert Mapplethorpe Interview."

CHRONOLOGY

1946

Robert Michael Mapplethorpe is born on November 4 to Joan and Harry Mapplethorpe in Queens, New York. He is their third child. There will be six children in the family, four boys and two girls.

1960

Enters Martin Van Buren High School in Queens. Studies the saxophone and excels in draftsmanship.

1963

Graduates from high school and leaves home to attend the Pratt Institute in Brooklyn. Majors in advertising design. Joins ROTC.

1965

Changes his major to graphic arts, concentrating on drawing, painting, and sculpture. Withdraws from ROTC.

1966

Mapplethorpe's work, largely psychedelic drawings and paintings, reflects his interest in William Blake and the surrealists.

1967

Meets Patti Smith, a former art major at Glassboro State College in New Jersey. She is visiting a friend at Pratt, an acquaintance of Mapplethorpe's. They soon move into an apartment near the school.

1967 *continued*

Employed by the New York children's store F.A.O. Schwarz as a window trimmer.

1968

Works primarily with collages, using Roman Catholic and black magic imagery. Inspired by Joseph Cornell and Marcel Duchamp, he begins to make boxes, triptychs, and altarpieces. Designs several large constructions that he is unable to execute because he lacks space and funds.

1969

Stops going to Pratt, and he and Patti Smith move to the Chelsea Hotel on 23d Street in Manhattan.

Frequents Max's Kansas City, a bar/restaurant near Union Square, where he and Patti Smith meet members of Andy Warhol's Factory: Gerard Malanga, Viva, Jackie Curtis, Danny Fields, Candy Darling.

Continues to work with mixed-media collages, introducing spray paint and sexual imagery clipped from magazines.

1969 *continued*

Designs and sells jewelry, including talisman necklaces incorporating exotic beads, feathers, and semiprecious stones.

Patti Smith and Mapplethorpe part as a couple but remain friends.

1970

Sandy Daley, an artist living at the Chelsea Hotel, makes a short film about Mapplethorpe entitled *Robert Having His Nipple Pierced*. Daley, who is experimenting with photographs on canvas, gives Mapplethorpe a Polaroid camera.

Moves with Patti Smith to a loft near the Chelsea Hotel, where he has more space and can build more elaborate constructions and installations.

1971

Introduced to John McKendry, curator of prints and photography at the Metropolitan Museum of Art, who shows Mapplethorpe and Patti Smith the museum's photography archives. Mapplethorpe is fascinated by the idea of photographs as fine art and by print-

ing processes. He is particularly drawn to
the work of Alfred Stieglitz and Paul Strand.

Is given a new Polaroid camera by John
McKendry and begins to concentrate on
taking photographs, primarily self-portraits.

Receives a small grant from the Polaroid
Corporation.

An exhibition of Mapplethorpe's collages
and constructions is mounted at the Chelsea
Hotel on November 4.

Robert Having His Nipple Pierced is shown at
the Museum of Modern Art, New York.

1972

Combs flea markets and thrift stores for old
tintypes and photographs.

Meets and develops a long-term intimate
relationship with the collector Sam Wag-
staff, who has recently left his position as
curator of contemporary painting and sculp-
ture at the Detroit Institute of Arts. Wag-
staff was formerly curator of paintings at the
Wadsworth Atheneum in Hartford, Con-
necticut.

Impressed by some photographs by Baron
von Gloeden that he sees in a private collec-
tion, Mapplethorpe encourages Wagstaff to
collect and invest in photographs.

Wagstaff buys a studio loft for Mapple-
thorpe at 24 Bond Street.

1973

Supported by Sam Wagstaff, Mapplethorpe
is able to create more ambitious and com-
plex constructions.

Begins using a large-format Polaroid cam-
era. Frames are incorporated as an integral
part of the finished work.

Mapplethorpe has his first solo gallery exhi-
bition, "Polaroids," at the Light Gallery in
New York.

Commissioned by Patti Smith to create the
cover for a book of her poems, *Witt*, which
is being published by the Gotham Book
Mart.

Exhibits some of his Polaroids with Brigid
Polk and Andy Warhol in a group show
mounted at the Gotham Book Mart.

1973 *continued*

Finances Patti Smith's independent recording "Hey Joe/Piss Factory," produced by Lenny Kaye.

1975

John McKendry dies at the age of 42.

Patti Smith signs a recording contract with Arista Records. Mapplethorpe shoots the cover for her album *Horses*.

1976

Sam Wagstaff gives Mapplethorpe a Hasselblad camera.

Mapplethorpe creates the cover for the rock group Television's album *Marquee Moon*.

Invited by Catherine Tennant to the Caribbean island of Mustique, a favorite vacation spot for British celebrities. He photographs Mick and Bianca Jagger, Princess Margaret, and other guests at Colin Tennant's Gold Ball, for *Interview* magazine.

In London, Mapplethorpe photographs the Lambtons, Marianne Faithfull, and various social figures.

1976 *continued*

Creates his first dye-transfer images, of the Archbishop of Canterbury, Patti Smith, John McKendry, and Allen Ginsberg.

1977

Becomes increasingly interested in photographing S&M subjects.

The Holly Solomon Gallery in New York sponsors two solo shows of Mapplethorpe's work.

"Erotic Pictures" is mounted at The Kitchen in New York.

Invited to take part in Documenta 6 in Kassel, West Germany.

1978

The Chrysler Museum in Norfolk, Virginia, publishes the first catalog to an exhibition of Mapplethorpe's work.

Directs short black-and-white film, *still moving/patti smith*.

Vintage photographs from Mapplethorpe's collection are exhibited at the University of California at Berkeley.

1978 *continued*

Shares two-artist exhibition with Patti Smith at the Robert Miller Gallery in New York.

Concentrates on portraits and figure studies of black men.

The Robert Miller Gallery becomes Robert Mapplethorpe's exclusive dealer.

Sam Wagstaff curates a traveling exhibition of his photography collection. A photograph by Mapplethorpe appears on the cover of the catalog.

The *X* and *Y* portfolios of S&M and flower images are published in limited editions by Harry Lunn, Robert Miller, and Robert Self.

Travels to San Francisco to attend openings of his exhibitions at the 80 Langton Street Gallery and the Simon Lowinsky Gallery.

Solo exhibitions: New York; Norfolk, Virginia; San Francisco; Paris; Los Angeles; Washington, D.C.

1979

Awarded grant by New York State Creative Artists Public Service Program (CAPS).

1979 *continued*

Begins working with the printer Tom Baril, who will remain Mapplethorpe's printer until the artist's death.

Mapplethorpe and the photographer Lynn Davis share a two-artist exhibition, "Trade-Off," at the International Center of Photography, New York.

Creates cover for Patti Smith's album *Wave*.

Solo exhibitions: New York, Amsterdam, Houston.

1980

Meets Lisa Lyon, first World Women's Bodybuilding Champion, at a party in New York. They begin collaborating on a series of portraits and figure studies of her.

Travels with Lisa Lyon to Joshua Tree, California; Fire Island, New York; and Amsterdam.

Ingrid Sischy, the editor of *Artforum* magazine, publishes six pages of Mapplethorpe's photographs of Lisa Lyon.

Solo exhibitions: Boston; San Francisco; Chicago; Brussels; Apeldoorn, Netherlands; Amsterdam.

1981

Moves to studio apartment at 77 Bleecker Street, where he lives with Milton Moore. Mapplethorpe keeps the studio on Bond Street.

Travels to Paris for the opening of his exhibition at the Galerie Texbraun.

Publishes limited-edition *Z* portfolio, photographs of black men.

Solo exhibitions: Washington, D.C.; New York; Paris; Brussels; San Francisco; Berlin; Los Angeles; Basel; Frankfurt.

1982

Travels to Jamaica and Los Angeles with Lisa Lyon.

Mapplethorpe's brother Edward becomes an assistant at the Bond Street studio. He will later use the name Edward Maxey for his own work as a photographer.

Jack Walls moves into the 77 Bleecker Street apartment.

Mapplethorpe sells his photography collection at auction at Sotheby's in New York. He continues to collect Arts and Crafts fur-

1982 *continued*

niture, 1950s Italian glass, Scandinavian ceramics, and photographs.

Solo exhibitions: Rome; Utrecht, Netherlands; Amsterdam; New Orleans; Atlanta; Los Angeles; Chicago; The Pines, Long Island; Tokyo.

1983

Begins collaborating with the designer and stylist Dimitri Levas.

Mapplethorpe and Andy Warhol take each other's portraits.

Retains Art + Commerce Agency to encourage editorial and advertising projects.

Lady, *Lisa Lyon* is published. Leo Castelli mounts a show of images from the book. *Elle* magazine in France publishes six pages of the Lyon portraits.

The Robert Miller Gallery exhibits some of Mapplethorpe's wall-mounted sculptures.

Mapplethorpe travels to Venice to attend the opening of an exhibition of his work at the Palazzo Fortuny. The show is controversial and the museum is closed to minors.

Travels to London with Sam Wagstaff, Ingrid Sischy, and Lisa Lyon for the opening of a retrospective at the Institute of Contemporary Arts.

Solo exhibitions: New York; Paris; London; Tokyo; Toronto; Milwaukee; Munich; Düsseldorf; Venice.

1984

Directs short color film about Lisa Lyon, *Lady*.

Is awarded $15,000 general support grant from the National Endowment for the Arts (NEA).

Travels to Madrid for opening of an exhibition of his work.

Designs coffee table later manufactured in a limited edition by Arc International.

Commissioned by Morgans Hotel in New York to create limited-edition photolithographs of flowers for guest rooms.

Travels to Japan with Sam Wagstaff for opening of an exhibition of his work in Tokyo.

Solo exhibitions: Naples; Madrid; Montreal; Tokyo; Hartford, Connecticut.

1985

Commissioned by Bruno Bischofberger to photograph a collection of art glass in Switzerland for a book to accompany a museum exhibition. The exhibition and the book are postponed, but several of the images will be used in Mapplethorpe's posthumous book *Flowers*.

Begins producing platinum prints.

Certain People: A Book of Portraits is published.

Creates cover for Joan Armatrading's album *Secret Secrets*.

Travels to Antwerp, Belgium, to photograph Jan Fabre's performance piece *The Power of Theatrical Madness*. The photographs are later collected in a book published by the Institute of Contemporary Arts in London.

Solo exhibitions: Paris; Lisbon; New York; Chicago; Atlanta; Milwaukee; San Francisco.

149

1986

Begins printing images in platinum on linen. Unique pieces are framed with panels of fabric. Also begins producing photogravures on silk.

Commissioned by Richard Marshall to take portraits for the book *50 New York Artists*.

Creates the set designs for "Portraits in Reflection," a dance piece by Lucinda Childs.

Black Book is published.

Creates photogravures for Arthur Rimbaud's *A Season in Hell*.

Creates cover for Taj Mahal's album *Taj*.

In September, Mapplethorpe is hospitalized with *Pneumocystis carinii* pneumonia and is diagnosed with AIDS.

Solo exhibitions: South Yarra, Australia; Chicago; Houston; New York; Bologna.

1987

Sam Wagstaff dies January 14 of complications resulting from AIDS. Mapplethorpe arranges Wagstaff's memorial service, which is held March 2 at the Metropolitan Museum

1987 *continued*

of Art. Mapplethorpe inherits the bulk of Wagstaff's estate.

Begins working on a series of flower photographs using the dye-transfer process.

Travels to Los Angeles to photograph Patti Smith for the cover of her album *Dream of Life*.

Robert Mapplethorpe is published in Japan.

Solo exhibitions: New York; New Orleans; Berlin; San Francisco; Piran, Yugoslavia; Geneva; Milan.

1988

Travels to Amsterdam and London for openings of exhibitions of his work.

Mapplethorpe's health deteriorates and he requires increasing assistance from friends. During the summer he is admitted to St. Vincent's Hospital twice, and has a Hickman catheter placed in his chest so he can receive intravenous antibiotics and nourishment.

Is the subject of television documentaries produced by the BBC and T.V. España.

Begins series of covers for *Splash* magazine.

Creates cover for Paul Simon album *Negotiations and Love Songs*.

In May, he establishes the Robert Mapplethorpe Foundation, a charitable organization designed to provide gifts for AIDS research and photography projects. The Foundation is the residuary beneficiary of his estate.

In July, Mapplethorpe's first American museum retrospective is presented by the Whitney Museum of American Art in New York. Mapplethorpe attends the opening reception.

A traveling exhibition is organized by the Institute of Contemporary Art (ICA) at the University of Pennsylvania, which has received a $30,000 grant from the NEA for this purpose. The Mapplethorpe Foundation makes its first grant, to the ICA to supplement the cost of producing a catalog for the exhibition.

The ICA show, "The Perfect Moment," opens in Philadelphia in December. Mapplethorpe is too ill to attend.

Solo exhibitions: New York; Washington, D.C.; Seattle; Amsterdam; Paris; London; Lucerne, Switzerland; Santa Monica, California; Philadelphia.

Sells the Wagstaff silver collection at an auction at Christie's in New York on January 20.

"The Perfect Moment" travels to the Museum of Contemporary Art in Chicago in February.

Creates cover for Laurie Anderson album *Strange Angels*.

Is admitted again to St. Vincent's Hospital.

Time magazine commissions Mapplethorpe to take a portrait of U.S. Surgeon General C. Everett Koop. It appears in the magazine's April 24 issue.

On March 1, Mapplethorpe travels to Boston's New England Deaconess Hospital to receive experimental CD4 treatment from Dr. Jerome Groopman. He is too ill to be admitted into the program.

Mapplethorpe dies at approximately 6 A.M. on March 9, of respiratory failure.

On March 14, the Mapplethorpe family holds a special funeral mass at Our Lady of the Snows, Floral Park, Queens.

On May 18, a memorial service is held for Mapplethorpe at the Whitney Museum of American Art.

Mapplethorpe's mother dies on May 28.

Two weeks before the July 1 opening date, "The Perfect Moment" is canceled by the board of directors of the Corcoran Gallery of Art in Washington, D.C. The gallery's director, Christina Orr-Cahall, cites political considerations for the cancellation, which creates widespread protest. The show becomes the center of a controversy about public funding of the arts, censorship, and the First Amendment. Senator Jesse Helms destroys a catalog of "The Perfect Moment" on the Senate floor and denounces it as pornographic.

"The Perfect Moment" is shown by the Washington Project for the Arts and has a

record attendance. It travels to the Wadsworth Atheneum in Hartford, Connecticut.

Mapplethorpe's collections of art, nineteenth- and twentieth-century photographs, glass, ceramics, and furniture are auctioned at Christie's in New York on October 31.

Some Women is published.

Solo exhibitions: New York; Kansas City, Missouri; Chicago; Santa Monica, California; Paris.

"The Perfect Moment" travels to the University of California at Berkeley in January.

"The Perfect Moment" opens at the Contemporary Arts Center in Cincinnati, Ohio, on April 7. Police close the gallery temporarily while they gather evidence. The museum and its director, Dennis Barrie, are indicted on counts of pandering obscenity and child pornography. The highly publicized case goes to trial in September, and Barrie and the museum are acquitted.

"The Perfect Moment" opens at the Institute of Contemporary Art in Boston in July.

Flowers is published.

The Robert Mapplethorpe Foundation moves to offices at 120 Wooster Street in

Manhattan in September. It continues to fund medical research and provide grants for photography projects.

EXHIBITIONS

SOLO EXHIBITIONS

Galerie Jurka, Amsterdam. Catalog with text by Rein van der Fuhr.

"Trade Off" (with Lynn Davis), International Center of Photography, New York.

1980

"Black Males," Galerie Jurka, Amsterdam. Catalog with text by Edmund White.

Vision Gallery, Boston.

"Robert Mapplethorpe: Blacks and Whites," Lawson/DeCelle Gallery, San Francisco.

In a Plain Brown Wrapper Gallery, Chicago.

Stuart Gallery, Chicago.

Contretype Gallery, Brussels.

Van Reekum Museum, Apeldoorn, Netherlands.

1981

Fraenkel Gallery, San Francisco.

Lunn Gallery, Washington, D.C.

Galerie Texbraun, Paris.

"Black Males," Robert Miller Gallery, New York.

"Robert Mapplethorpe," Kunstverein, Frankfurt. Traveled to Fotogalerie Forum Stadtpark, Graz, Austria; Modern Art Galerie, Vienna; PPS Galerie F.C. Gundlach, Hamburg; Kunsthalle, Basel; Kunstverein, Munich; and Nikon Foto Galerie, Zurich. Catalog with text by Sam Wagstaff and Peter Weiermair.

Galerie Nagel, Berlin.

Galerie Contretype, Brussels.

"Recent Photographs," ACE Gallery, Los Angeles.

"ART 12 '81," Galerie Jurka, Basel.

1982

"Black Males," Galleria il Ponte, Rome.

"Robert Mapplethorpe Fotos," Galerie Ton Peek, Utrecht, Netherlands.

Fay Gold Gallery, Atlanta.

Young Hoffman Gallery, Chicago.

Larry Gagosian Gallery, Los Angeles.

Shore Gallery, The Pines, Long Island, New York.

"Recent Work," Galerie Jurka, Amsterdam.

Contemporary Arts Center, New Orleans.

Galerie Watari, Tokyo.

1983

"New Works," Robert Miller Gallery, New York.

"Recent Work," Hardison Fine Arts Gallery, New York.

"Lady, Lisa Lyon," Leo Castelli Gallery, New York. Traveled to Rüdiger Schöttle Galerie, Munich; Photografie Galerie, Düsseldorf; Olympus Centre, London.

Michael Lord Gallery, Milwaukee.

Jane Corkin Gallery, Toronto.

Centre National d'Art et de Culture Georges Pompidou, Paris.

"Robert Mapplethorpe Flowers," Galerie Watari, Tokyo. Catalog with text by Sam Wagstaff.

"Robert Mapplethorpe, 1970–1983," Institute of Contemporary Arts, London. Traveled to Stills, Edinburgh; Arnolfini, Bristol; Midland Group, Nottingham; and Museum of Modern Art, Oxford. Catalog with text by Stuart Morgan and Alan Hollinghurst.

"Photogravures–1983," Barbara Gladstone Gallery, New York.

"Robert Mapplethorpe Fotografie," Centro di Documentazione di Palazzo Fortuny, Venice. Traveled to Palazzo delle Cento Finestre, Florence. Catalog with text by Germano Celant.

"The Agency," Hardison Fine Arts Gallery, New York. Catalog.

Franco American Institute, Rennes.

1984

"Robert Mapplethorpe Fotografias, 1970–1983," Galeria Fernando Vijande, Madrid.

"Robert Mapplethorpe: Photographies, 1978–1984," John A. Schweitzer Gallery, Montreal.

157

1984 *continued*

"Lady," Hara Museum of Contemporary Art, Tokyo. Catalog.

"Matrix 80," Wadsworth Atheneum, Hartford.

Fondazione Lucio Amelio, Naples.

1985

Galerie Daniel Templon, Paris.

"Robert Mapplethorpe: New Works in Platinum," Robert Miller Gallery, New York.

"Black Flowers," Galeria Cómicos, Lisbon.

"Robert Mapplethorpe: Process," Barbara Gladstone Gallery, New York. Brochure with essay by Sam Wagstaff.

Betsy Rosenfield Gallery, Chicago.

Fay Gold Gallery, Atlanta.

Michael Lord Gallery, Milwaukee.

"Recent Works in Platinum," Fraenkel Gallery, San Francisco.

1986

"Robert Mapplethorpe: Photographs 1976–1985," Australian Center for Contemporary Art, South Yarra, Victoria. Catalog with text by Paul Foss.

1986 *continued*

Palazzo d' Accursio, Bologna. Catalog by Germano Celant.

Betsy Rosenfield Gallery, Chicago.

Texas Gallery, Houston.

"New Photographs," Palladium, New York.

1987

Robert Miller Gallery, New York.

Julia Gallery, New Orleans.

"Robert Mapplethorpe 1986," Raab Galerie, Berlin; Kicken-Pauseback, Cologne. Catalog with interview by Anne Horton.

Fraenkel Gallery, San Francisco.

Obalne Galerije, Piran, Yugoslavia. Catalog with text by Germano Celant.

Galerie Pierre-Hubert, Geneva.

Galerie Françoise Lambert, Milan.

Claus Runkel Fine Art, London.

1988

"Robert Mapplethorpe," Stedelijk Museum, Amsterdam. Traveled to Centre National d'Art et de Culture Georges Pompidou, Paris. Catalog with text by Els Barents.

158

"Mapplethorpe Portraits," National Portrait Gallery, London. Catalog with text by Peter Conrad.

Whitney Museum of American Art, New York. Catalog with text by Richard Marshall et al.

"Robert Mapplethorpe: The Perfect Moment," Institute of Contemporary Art, University of Pennsylvania, Philadelphia. Traveled to Museum of Contemporary Art, Chicago; Washington Project for the Arts, Washington, D.C.; Wadsworth Atheneum, Hartford; University Art Museum, University of California, Berkeley; Contemporary Arts Center, Cincinnati; and Institute of Contemporary Art, Boston. Catalog with text by Janet Kardon, David Joselit, Kay Larson, and Patti Smith.

"Photographien" (with Thomas Ruff), Mai 36 Galerie, Lucerne.

"New Color Work," Robert Miller Gallery, New York.

Hamiltons Gallery, London.

Galerie Jurka, Amsterdam.

Middendorf Gallery, Washington, D.C.

Betsy Rosenfield Gallery, Chicago.

"Autoportraits," Grand Palais, Paris.

Blum Helman Gallery, Santa Monica, California.

"A Season in Hell," Greg Kucera Gallery, Seattle.

1989

Bridgewater/Lustberg, New York.

"The Modernist Still Life—Photographed," University of Missouri, Kansas City.

Betsy Rosenfield Gallery, Chicago.

Blum Helman Gallery, Santa Monica, California.

Baudoin Lebon, Paris.

Fraenkel Gallery, San Francisco.

"Robert Mapplethorpe—Een Retrospectieve," Museum van Hedendaagse Kunst, Citadelpark, Gent.

1990

Martina Hamilton Gallery, New York.

159

1991

"Robert Mapplethorpe: Early Works," Robert Miller Gallery, New York. Catalog.

Galeria Weber, Alexander y Cobo, Madrid. Catalog with text by Jorge Ribalta.

"Lady," ACE Gallery, Los Angeles.

"Robert Mapplethorpe," Musée d'Art Contemporain, Fondation Edelman, Pully/Lausanne, Switzerland. Catalog with text by Chantal Michetti and C. A. Riley.

Galerie Franck + Schulte, Berlin.

160

1992

"Mapplethorpe versus Rodin," Kunsthalle Düsseldorf. Catalog with text by Germano Celant.

"Robert Mapplethorpe," Louisiana Museum of Modern Art, Humlebaek, Denmark. Traveled to Centro di Documentazione di Palazzo Fortuny, Venice; Moderna Museet, Stockholm; and Castello di Rivoli Museo d'Arte Contemporanea, Turin. Catalog with text by Germano Celant.

"Robert Mapplethorpe," Museo de Monterrey, Monterrey, Mexico. Catalog with essay by Jorge Garcia Murillo.

1992 *continued*

"Robert Mapplethorpe," Tokyo Teien Museum, Tokyo. Catalog.

I.C.A.C. Weston Gallery, Tokyo.

Robert Mapplethorpe Retrospective, Louisiana Museum, Humlebaek, Denmark. Traveled to Museum fuer Kunst und Gewerbe, Hamburg, and Palazzo Fortuny, Venice.

1993

Moderna Museet, Stockholm.

Turun Taidemuseo, Turku, Finland.

Palais des Beaux Arts, Brussels.

Centro per l'arte contemporanea Luigi Pecci, Prato.

"Robert Mapplethorpe/Elsa Reddy," Santa Barbara Museum of Art, Santa Barbara, California.

"Robert Mapplethorpe Polaroids," Robert Miller Gallery, New York.

"Robert Mapplethorpe Self-Portraits," Solomon R. Guggenheim Museum, New York.

GROUP EXHIBITIONS

1973

"Polaroids: Robert Mapplethorpe, Brigid Polk, Andy Warhol," Gotham Book Mart, New York.

1974

"Recent Religious and Ritual Art," Buecker and Harpsichords, New York.

"Group Exhibition," Bykert Gallery, New York.

1976

"Animals," Holly Solomon Gallery, New York.

"Summer Group Exhibition," Holly Solomon Gallery, New York.

1977

"Surrogates/Self-portraits," Holly Solomon Gallery, New York.

Documenta 6, Museum Fridericianum, Kassel, West Germany. Catalog with text by Manfred Schneckenburger.

1978

"The New York Boat Show," Holly Solomon Gallery, New York.

"The Collection of Sam Wagstaff," Corcoran Gallery of Art, Washington, D.C. Traveled to St. Louis Art Museum; Grey Art Gallery and Study Center, New York University, New York; Seattle Art Museum; University Art Museum, University of California, Berkeley; and High Museum, Atlanta. Checklist by Jane Livingston.

"Mirrors and Windows: American Photography Since 1960," Museum of Modern Art, New York. Traveled to Cleveland Museum of Art; Walker Art Center, Minneapolis; J. B. Speed Museum, Louisville, Kentucky; Museum of Modern Art, San Francisco; Krannert Art Museum, University of Illinois, Champaign; Virginia Museum of Fine Arts, Richmond; and Milwaukee Art Center. Catalog with text by John Szarkowski.

"Rated X," Marge Neikrug Gallery, New York.

1979

"People Watching," Museum of Modern Art, New York.

Robert Samuel Gallery, New York.

"Attitudes," Santa Barbara Museum of Art. Catalog with text by Fred Parker.

"Artists by Artists," Whitney Museum of American Art, Downtown Branch, New York.

"American Portraits of the Sixties and Seventies," Aspen Center for the Visual Arts, Aspen, Colorado. Catalog with text by Julie Augur.

1980

"Secret Paintings (Erotic Paintings and Photographs)," Jehu Gallery, San Francisco.

"Presences: The Figure and Manmade Environments," Freedman Gallery, Albright College, Reading, Pennsylvania. Catalog with text by Bruce Sheftel.

"In Photography, Color as Subject," School of Visual Arts Museum, New York.

1980 *continued*

"Quattro fotografi differenti," Padiglione d'Arte Contemporanea, Milan. Catalog by Carol Squiers.

"New Visions," Carson-Sapiro Gallery, Denver.

"The Norman Fisher Collection," Jacksonville Art Museum, Jacksonville, Florida. Catalog with text by Ted Castle et al.

1981

"Lichtbildnisse: Das Porträt in der Fotografie," Rheinisches Landesmuseum, Bonn.

"Marked Photographs," Robert Samuel Gallery, New York.

"Autoportraits photographiques," Centre National d'Art et de Culture Georges Pompidou, Paris. Catalog by Denis Roche.

"New York, New Wave," Institute for Art and Urban Resources, P.S. 1, Long Island City, New York.

"Land/Urban Scapes," Islip Town Center, Islip, New York. Checklist with text by Jeanette Ingberman.

1981 *continued*

"Inside Out—Self Beyond Likeness," Newport Harbor Art Museum, Newport Beach, California. Traveled to Portland Art Museum, Portland, Oregon, and Joslyn Art Museum, Omaha, Nebraska. Catalog with text by Lynn Gamwell.

1981 Biennial Exhibition, Whitney Museum of American Art, New York. Catalog.

"Figures: Forms and Expressions," Albright-Knox Art Gallery, Buffalo. Catalog with text by Robert Collingnon and Biff Henrich.

"US Art Now," Nordiska Kompaniet, Stockholm; Götesborgs Kunstmuseum, Götesborg, Sweden. Catalog with text by Lars Peder Hedberg.

"Surrealist Photographic Portraits: 1920–1980," Marlborough Gallery, New York. Catalog with text by Dennis Longwell.

"Instant Fotografie," Stedelijk Museum, Amsterdam. Catalog with text by Els Barents in collaboration with Karel Schampers.

1982

"Counterparts: Form and Emotion in Photographs," Metropolitan Museum of Art, New York. Catalog with text by Weston J. Naef.

"The Black Male Image," Harlem Exhibition Space, New York.

"Faces Photographed," Grey Art Gallery and Study Center, New York University, New York. Catalog with text by Ben Lifson.

"Points of View," Museum of Art, University of Oklahoma, Norman. Catalog with text by Sam Olkinetzky.

Documenta 7, Kassel, West Germany. Catalog with text by Rudi Fuchs.

"La photographie en Amérique," Galerie Texbraun, Paris.

"Lichtbildnisse," Rheinisches Landesmuseum, Bonn.

"The Erotic Impulse," Concord Gallery, New York.

"Portraits," Concord Gallery, New York.

"Intimate Architecture: Contemporary Clothing Design," Hayden Gallery, List

1982 *continued*

Visual Arts Center, Massachusetts Institute of Technology, Cambridge. Catalog with text by Susan Sidlauskas.

"The Crucifix Show," Barbara Gladstone Gallery, New York.

1983

Photografie Galerie, Düsseldorf.

"Three-Dimensional Photographs," Castelli Graphics, New York.

"Presentation: Recent Portrait Photography," Taft Museum, Cincinnati. Catalog with text by Janet Borden.

"Phototypes," Whitney Museum of American Art, Downtown Branch, New York. Checklist with text by Philip Hotchkiss Walsh et al.

"Drawings and Photographs," Leo Castelli Gallery, New York.

"Self-portraits," Linda Farris Gallery, Seattle; Los Angeles Municipal Art Gallery. Catalog with text by Peter Frank.

1983 *continued*

"Photography in America 1910–1983," Tampa Museum, Tampa, Florida. Catalog with text by Julie M. Saul.

"New Art," Tate Gallery, London.

"New Perspectives on the Nude," The Foto Gallery, Cardiff, Wales.

"The Horse Show," Robert Freidus Gallery, New York.

1984

"Investigations 10, Face to Face: Recent Portrait Photography," Institute of Contemporary Art, University of Pennsylvania, Philadelphia. Catalog with text by Paula Marincola.

"Twelve on 20 × 24," organized by New England Foundation for the Arts, Cambridge. Traveled to Gallery of the School of Fine Arts, Boston; Westbrook College, Portland, Maine; Fitchburg Art Museum, Fitchburg, Massachusetts; Smith College Museum, Northampton, Massachusetts; and Honolulu Academy of Arts. Catalog with text by Jon Holmes.

"Flower as Image in 20th-Century Photography," Wave Hill, Bronx, New York. Catalog with text by Linda Macklowe.

"Terrae Motus," Fondazione Amelio, Naples. Catalog with text by Giulio Carlo Argan et al.

"Radical Photography: The Bizarre Image," Nexus Gallery, Atlanta. Catalog with text by Eric D. Bookhardt.

"Portrait Photography," Delahunty Gallery, Dallas.

"Sex," Cable Gallery, New York.

"Sex-Specific: Photographic Investigations of Contemporary Sexuality," Superior Street Gallery, School of the Art Institute of Chicago. Catalog with text by Joyce Fernandes.

"Still-Life Photographs," Jason McCoy Inc., New York.

"Allegories of the Human Form: A Photography Exhibit," Dowd Fine Arts Center Gallery, State University of New York, Cortland.

"The Heroic Figure," Contemporary Arts Museum, Houston. Traveled to Memphis Brooks Museum of Art, Memphis, Tennessee; Alexandria Museum/Visual Art Center, Alexandria, Louisiana; and Santa Barbara Museum of Art, Santa Barbara, California. Catalog with text by Linda Cathcart and Craig Owens.

"Second Salon of Montreal Art Galleries," Palais des Congrès, Montreal.

"Photography—New Directions," Provincetown Art Association and Museum, Provincetown, Massachusetts.

"Armed," Interim Art, London.

1985

"Five Years with 'The Face,'" Photographers' Gallery, London.

"Image, Insight: Photographic Intuitions of the 1980s," Islip Art Museum, East Islip, New York.

"Nude, Naked, Stripped," Hayden Gallery, List Visual Arts Center, Massachusetts Institute of Technology, Cambridge. Catalog with text by Carrie Rickey.

1985 *continued*

"Beautiful Photographs," One Penn Plaza, New York.

"The New Figure," Birmingham Museum of Art, Birmingham, Alabama.

"Messages from 1985," Light Gallery, New York.

"Picture-Taking: Weegee, Walker Evans, Sherrie Levine, Robert Mapplethorpe," Mary and Leigh Block Gallery, Northwestern University, Evanston, Illinois. Catalog with text by William Olander.

"Entertainment," Josh Baer Gallery, New York.

"Flowers: Varied Perspectives," Patricia Heesy Gallery, New York.

"Beauty," Palladium, New York.

"Big Portraits," Jeffrey Hoffeld & Co., New York.

Fraenkel Gallery, San Francisco.

"Self-Portrait: The Photographer's Persona 1840–1985," Museum of Modern Art, New York.

1985 *continued*

"Home Work," Holly Solomon Gallery, New York.

"Marcus Leatherdale, Robert Mapplethorpe, Laurie Simmons," Jason McCoy Gallery, New York.

"Style: An Exhibition of Fashion Photographs," Vision Gallery, Boston.

"Memento Mori," Moore College of Art, Philadelphia.

1986

"Paravent," Artspace, San Francisco.

"The Nude in Modern Photography," San Francisco Museum of Modern Art.

"OSO Bay Biennial," Corpus Christi State University, Corpus Christi, Texas.

"Rules of the Game: Culture Defining Gender," Mead Art Museum, Amherst College, Amherst, Massachusetts. Catalog with text by Judith Barter and Anne Mochon.

Edwynn Houk Gallery, Chicago.

"intimate/INTIMATE," Turman Gallery, Indiana State University, Terre Haute, Indi-

ana. Catalog with text by Charles S. Mayer and Bert Brouwer.

"Sacred Images in Secular Art," Whitney Museum of American Art, Downtown Branch, New York.

Bentler Galleries Inc., Houston.

"A Matter of Scale," Rockland Center for the Arts and Blue Hill Plaza Associates, Pearl River, New York.

"Contemporary Issues III," Holman Hall Art Gallery, Trenton State College, Trenton, New Jersey. Catalog with text by Lois Fichner-Rathus.

"The Sacred and the Sacrilegious: Iconographic Images in Photography," Photographic Resource Center, Boston.

"Invitation: La revue Parkett," Centre National d'Art et de Culture Georges Pompidou, Paris.

"Midtown Review," International Center of Photography/Midtown, New York.

"Staging the Self," National Portrait Gallery and Plymouth Arts Centre, London.

"Art & Advertising, Commercial Photography by Artists," International Center of Photography, New York. Catalog with text by Willis Hartshorn.

"The Fashionable Image: Unconventional Fashion Photography," Mint Museum, Charlotte, North Carolina. Catalog with text by Henry Barendse.

"The First Decade," Freedman Gallery, Albright College, Reading, Pennsylvania.

1987

"Portrait: Faces of the '80s," Virginia Museum of Fine Arts, Richmond. Catalog with text by George Cruger.

"Il nudo maschile nella fotografia 19th–20th c.," Commune di Ravenna, Ravenna, Italy.

"Legacy of Light," International Center of Photography, New York.

"Of People and Places: The Floyd and Josephine Segal Collection of Photography," Milwaukee Art Museum. Catalog with text by Verna Posever Curtis.

167

1987 *continued*

"Photographers Who Make Films," Catskill Center for Photography, Woodstock, New York. Traveled to Department of Photography and Cinema Studies, New York University, New York.

"Contemporary American Figurative Photography," Center for the Fine Arts, Miami.

1988

"First Person Singular: Self-portrait Photography, 1840–1987," High Museum at Georgia-Pacific Center, Atlanta. Catalog with text by Ellen Dugan.

"Fotofest 88," Houston.

"The Return of the Hero," Burden Gallery, Aperture Foundation, New York.

"Flowers," Grand Rapids Museum, Grand Rapids, Michigan.

"LifeLike," Lorence-Monk Gallery, New York.

Barbara Gladstone Gallery, New York.

"Identity: Representations of the Self," Whitney Museum of American Art, Federal Reserve Plaza, New York.

1988 *continued*

"The Flower Show," Betsy Rosenfield Greenhouse, Chicago.

1989

"Photography Now," Victoria and Albert Museum, London. Catalog with text by Mark Haworth-Booth.

"Das Porträt in der zeitgenossischen Photographie," Frankfurter Kunstverein, Frankfurt. Traveled to Kulturzentrum Mainz, Mainz, Germany, and Galerie Fotohof, Salzburg, Austria. Catalog with text by Peter Weiermair.

"150 Years of Photography," National Gallery of Art, Washington, D.C. Traveled to Art Institute of Chicago and Los Angeles County Museum of Art.

"The Legacy of William Henry Fox Talbot," Burden Gallery, Aperture Foundation, New York.

"Group Show," Betsy Rosenfield Gallery, Chicago.

"L'invention d'un art," Centre National d'Art et de Culture Georges Pompidou, Paris.

"Taboo," Greg Kucera Gallery, Seattle.

"Self and Shadow," Burden Gallery, Aperture Foundation, New York.

Museo de Arte Contemporaneo de Caracas, Venezuela.

"To Probe & to Push: Artists of Provocation," Wessel O'Connor Gallery, New York.

"Les Krims, Bruce Weber, William Klein, Irving Penn, Duane Michaels, Robert Mapplethorpe," Mai 36 Galerie, Lucerne, Switzerland.

1990

"The Indomitable Spirit," International Center of Photography/Midtown, New York. Traveled to Lorence Monk Gallery, New York; Pace-MacGill Gallery, New York; Fraenkel Gallery, San Francisco; Rhona Hoffman Gallery, Chicago; Blum Helman Gallery, Santa Monica, California; Los Angeles Municipal Art Gallery; AIPAD Special Exhibition at Basel Art Fair, Basel, Switzerland; A Gallery for Fine Photography, New Orleans; and Fay Gold Gallery, Atlanta.

"Botanica: The Secret Life of Plants," Lehman College Art Gallery, City University of New York, New York.

"Disturb Me," Massimo Audiello Gallery, New York.

"The Humanist Icon," Bayly Art Museum, University of Virginia, Charlottesville. Traveled to New York Academy of Art, New York, and Edwin A. Ulrich Museum of Art, Wichita State University, Kansas.

"Robert Mapplethorpe Flowers/André Kertész Vintage Photographs," G. Ray Hawkins Gallery, Los Angeles.

"The Art of Photography: 1839–1989," Seibu Museum of Art, Tokyo.

Art in Embassies Program, United States Embassy, Mexico City.

"Great Contemporary Nudes 1978–1990," C Two Gallery, Tokyo.

"Modern Art Market '90," Matsuya Department Store, Ginza, Tokyo.

"The Last Decade: American Artists of the '80s," Tony Shafrazi Gallery, New York.

1990 *continued*

"Altered Truths," New Orleans Museum of Art.

"Art in Bloom," A. P. Giannini Gallery, San Francisco.

"Art That Happens to Be Photography," Texas Gallery, Houston.

"Vollbild AIDS," Damptzentrale, Bern, Switzerland. Traveled to Fondation Deutsch, Lausanne, Switzerland.

"The Fugitive Gesture," Duke University Museum of Art, Durham, North Carolina.

"Faces," Marc Richards Gallery, Los Angeles.

"Jan Fabre Theaterarbeiten, Fotografien von Robert Mapplethorpe, Helmut Newton und Carl De Keyzer," Fotogalerie Forum, Frankfurt.

"Von der Natur in der Kunst," Messepalast, Vienna.

1991

"Fashion Photography Since 1945," Victoria and Albert Museum, London. *Appearances:*

1991 *continued*

Fashion Photography Since *1945*, with text by Martin Harrison, published to accompany show.

"Twentieth-Century Collage," Margo Leavin Gallery, Los Angeles. Traveled to Centro Cultural Arte Contemporaneo, Mexico City, and Musée d'Art Moderne et d'Art Contemporain, Nice.

"7 Women," Andrea Rosen Gallery, New York.

"The Body in Question," Burden Gallery, Aperture Foundation, New York.

"The Power of Theatrical Madness," Fotogalerie Forum, Frankfurt.

"Modern Botanical," I.C.A.C. Weston Gallery, Carmel, California.

National Gallery of Victoria, Melbourne, Australia.

"Erotic Desire," Perspektief Rotterdam, Rotterdam, Netherlands.

"La revanche de l'image," Galerie Pierre Huber, Geneva.

"Framed," Stephen Wirtz Gallery, San Francisco.

"Cruciformed: Images of the Cross Since 1980," Cleveland Center for Contemporary Art. Traveled to Museum of Contemporary Art at Wright State University, Dayton, Ohio, and St. Lawrence University, Canton, New York.

"Photography from 1980 to 1990," Ginny Williams Gallery, Denver.

Galerie Nikolaus Sonne, Berlin.

1992

"Portraits," Klarfeld Perry Gallery, New York.

"The Midtown Flower Show," Midtown Payson Galleries, New York. Traveled to Portland Museum of Art, Portland, Maine.

"Flora Photographica," Royal Botanical Garden, Edinburgh. Traveled to Manchester City Art Gallery; Mead Gallery, Coventry; Vancouver Art Gallery.

"The Modernist Still Life Photographed," University of Missouri, St. Louis. Traveled to Greece, Algeria, and Morocco.

"This Sporting Life, 1978–1991," High Museum of Art, Atlanta. Traveled to University of Houston; Delaware Art Museum; Albright-Knox Gallery, Buffalo.

1993

"The Image of the Body," Frankfurter Kunstverein, Frankfurt.

"Several Exceptionally Good Recently Acquired Pictures VII," Fraenkel Gallery, San Francisco.

"Here's Looking at Me/A Mes Beaux Yeux," ELAC, Art Contemporain, Lyon.

"High Heeled Art," Center of Contemporary Art, North Miami, Florida. Traveled to Charles Cowles Gallery, New York.

"Facing History: Portraits from the National Archives of Canada," National Archives of Canada, Ottawa.

"William and Phyllis Mack Collection," Institute of Contemporary Art, Philadelphia.

"Photographic Self-Portraits from the Audrey and Sydney Irmas Collection," Los Angeles County Museum of Art.

"Abject Art," Whitney Museum of American Art, New York.

"Almadovar," Venice Biennial.

"I am the Enunciation," Threading Wax Space, New York.

"Blooming: The Art of Nature," Renée Fotouhi Fine Art, East Hampton, New York.

"Supreme Shots—Fashion Photography since 1948," Galleria Photology, Milan.

"Azure," Cartier Foundation, Jouy-en-Josas, France.

"25 Years," Cleveland Center for Contemporary Art.

"A Moment Becomes Eternity: Flowers as Image," Bergen Museum of Art and Science, Paramus, New Jersey.

"Artists of the Gallery," Galerie Franck Schulte, Berlin.

1994

"Fictions of the Self: The Portrait in Contemporary Photography," Weatherspoon Art Gallery, University of North Carolina at Greensboro. Traveled to Herter Art Gallery, University of Massachusetts at Amherst; Palazzio del Exhibition, Rome; Musée d'Art Moderne, Nice.

172

PUBLIC COLLECTIONS

Art Institute of Chicago, Illinois
Australian National Gallery, Canberra, Australia

Bank of America Collection, San Francisco, California
Boston Museum of Fine Arts, Massachusetts

Bowdoin College Museum of Art, Brunswick, Maine

Center for Creative Photography, University of Arizona

Centre Pompidou, Paris, France

Chase Manhattan Bank Collection, New York

Chrysler Museum, Norfolk, Virginia

Corcoran Gallery of Art, Washington, D.C.

Dallas Museum of Fine Arts, Michigan

Frankfurter Kunstverein, Frankfurt, Germany

George Eastman House, Rochester, New York

Getty Museum, Malibu, California

Hara Museum of Contemporary Art, Tokyo, Japan

High Museum of Art, Atlanta, Georgia

International Center of Photography, New York

Israel Museum, Jerusalem, Israel

La Jolla Museum of Contemporary Art, California

Los Angeles County Museum of Art, California

Madison Art Center, Wisconsin

Metropolitan Museum of Art, New York

Museum Ludwig, Cologne, Germany

Museum of Art, Norman, Oklahoma

Museum of Fine Arts, Houston, Texas

Museum of Modern Art, New York

National Archives of Canada, Ottawa

National Portrait Gallery, London

New Orleans Museum of Art, Louisiana

Portland Center of the Visual Arts, California

San Francisco Museum of Modern Art, California

Stedelijk Museum, Amsterdam, The Netherlands

Victoria & Albert Museum, London

Wadsworth Atheneum, Hartford, Connecticut

Whitney Museum of American Art, New York

173

BIBLIOGRAPHY

CATALOGS

Amaya, Mario. *Robert Mapplethorpe Photographs*. Norfolk, Virginia: Chrysler Museum, 1978.

Augur, Julie. *American Portraits of the Sixties and Seventies*. Aspen, Colorado: Aspen Center for the Visual Arts, 1979.

Baker, Lauren, Jennifer Dowd, and Philip Hotchkiss Walsh. *Phototypes: The Development of Photography in New York City* (brochure). New York: Whitney Museum of American Art, Downtown Branch, 1983.

Barendse, Henry. *The Fashionable Image: Unconventional Fashion Photography*. Charlotte, North Carolina: Mint Museum, 1986.

Barents, Els. *Robert Mapplethorpe*. Amsterdam: Stedelijk Museum, 1988.

———. *Ten by Ten*. Munich: Schirmer/Mosel, 1988.

Barents, Els, in collaboration with Karel Schampers. *Instant Fotografie*. Amsterdam: Stedelijk Museum, 1981.

Barter, Judith, and Anne Mochon. *Rules of the Game: Culture Defining Gender*. Amherst, Massachusetts: Mead Art Museum, Amherst College, 1986.

Becher, Mapplethorpe, Sherman. Monterrey, Mexico: Museo de Monterrey, 1992.

Black Flowers. Madrid: Fernando Vijando, 1985.

Bonuomo, Michele, and Diego Cortez. *Terrae motus*. Naples: Electa, 1984.

Bookhardt, Eric D. *Radical Photography: The Bizzarre Image*. Atlanta: Nexus Gallery, 1984.

Borden, Janet. *Presentation: Recent Portrait Photography*. Cincinnati: Taft Museum, 1983.

Cathcart, Linda, and Craig Owens. *The Heroic Figure*. Houston: Contemporary Arts Museum, 1984.

Celant, Germano. *Robert Mapplethorpe Fotografie*. Milan: Idea Books Edizioni; Venice: Centro di Documentazione di Palazzo Fortuny, 1983.

———. *Robert Mapplethorpe*. Piran, Yugoslavia: Obalne Galerije, 1986.

———. *Robert Mapplethorpe*. Milan: Idea Books Edizioni, 1986.

———. *Mapplethorpe*. Milan: Electa, 1992.

———. *Mapplethorpe versus Rodin*. Milan: Electa, 1992.

Celant, Germano, and Kathy Acker. *The Power of Theatrical Madness*. London: Institute of Contemporary Arts, 1986.

Cheim, John, ed. *Robert Mapplethorpe: Early Works*. New York: Robert Miller Gallery, 1991.

Collingnon, Robert, et al. *Figures: Forms and Expressions*. Buffalo: Albright-Knox Art Gallery, 1981.

Compton, Michael. *New Art*. London: Tate Gallery, 1983.

Conrad, Peter. *Mapplethorpe Portraits*. Foreword by Robin Gibson and Terence Pepper. London: National Portrait Gallery Publications, 1988.

Cruger, George. *Portrait: Faces of the '80s*. Richmond, Virginia: Virginia Museum of Fine Arts, 1987.

Curtis, Verna Posever. *Of People and Places: The Floyd and Josephine Segal Collection of Photography*. Foreword by Russell Bowman, essay by Robert M. Tilendis. Milwaukee: Milwaukee Art Museum, 1987.

Dugan, Ellen. *First Person Singular: Self-Portrait Photography, 1840–1987*. Atlanta: High Museum at Georgia-Pacific Center, 1988.

Danto, Arthur C. *Mapplethorpe*. New York: Random House, 1992.

Fernandes, Joyce. *Sex-Specific: Photographic Investigations of Contemporary Sexuality*. Chicago: School of the Art Institute of Chicago, 1984.

Foss, Paul. *Robert Mapplethorpe: Photographs 1976–1985*. South Yarra: Australian Center for Contemporary Art, 1986.

Frank, Peter. *Self-portraits*. Seattle: Linda Farris Gallery, 1983.

Friis-Hansen, Dana. *Nude, Naked, Stripped*. Essay by Carrie Rickey. Cambridge: Hayden Gallery, List Visual Arts Center, Massachusetts Institute of Technology, 1985.

Fuchs, Rudi. *Documenta 7*. Kassel, West Germany: Documenta, 1982.

Fuhr, Rein von der. *Robert Mapplethorpe*. Amsterdam: Galerie Jurka, 1979.

Gamwell, Lynn, and Victoria Kogan. *Inside Out—Self Beyond Likeness*. Newport Beach, California: Newport Harbor Museum, 1981.

Grynsztejn, Madeline, Junko Iwabuchi, Brooke Kamin, Lisa Suzuki, and Helen Woodall. *Sacred Images in Secular Art* (brochure). New York: Whitney Museum of American Art, 1986.

Hanhardt, John G., Barbara Haskell, Richard Marshall, and Patterson Sims. *1981 Biennial Exhibition*. New York: Whitney Museum of American Art, 1981.

Harrison, Martin. *Appearances: Fashion Photography Since 1945*. London: Jonathan Cape Ltd., 1991.

Hartshorn, Willis. *Art & Advertising, Commercial Photography by Artists*. New York: International Center of Photography, 1986.

Hedberg, Lars Peder. *US Art Now*. Foreword by Jan Eric Lowenadler. Stockholm: Nordiska Kompaniet, 1981.

Holmes, Jon. *Twelve on 20 × 24*. Introduction by Jim Field. Cambridge: New England Foundation for the Arts, 1984.

Horton, Anne. Interview. *Robert Mapplethorpe 1986*. Berlin: Raab Galerie; Cologne: Kicken-Pauseback, 1986.

Kardon, Janet, David Joselit, Kay Larson, and Patti Smith. *The Perfect Moment*. Philadelphia: Institute of Contemporary Art, University of Pennsylvania, 1988.

Lady. Tokyo: Hara Museum of Contemporary Art, 1984.

Lifson, Ben. *Faces Photographed*. New York: Grey Art Gallery and Study Center, New York University, 1982.

Livingston, Jane. *The Collection of Sam Wagstaff*. Washington, D.C.: Corcoran Gallery of Art, 1977.

Longwell, Dennis. *Surrealist Photographic Portraits 1920–1980*. New York: Marlborough Gallery, 1981.

Macklowe, Linda. *Flower as Image in 20th-Century Photography*. Foreword by Helen Gee. Bronx, New York: Wave Hill, 1984.

Mapplethorpe. Lausanne, Switzerland: FAE Musée d'Art Contemporain, 1992.

Marincola, Paula. *Investigations 10, Face to Face: Recent Portrait Photography*. Philadelphia: Institute of Contemporary Art, University of Pennsylvania, 1984.

Marshall, Richard, Richard Howard, and Ingrid Sischy. *Robert Mapplethorpe*. New York: Whitney Museum of American Art, in association with New York Graphic Society Books and Little, Brown and Company, 1988.

Mayer, Charles S. *intimate/INTIMATE*. Introduction by Bert Brouwer. Terre Haute: Turman Gallery, Indiana State University, 1986.

Michetti, C., and C. A. Riley. *Robert Mapplethorpe*. Pully-Lausanne, Switzerland: FAE Musée d'Art Contemporain, 1991.

Morgan, Stuart, and Alan Hollinghurst. *Robert Mapplethorpe, 1970–1983*. London: Institute of Contemporary Arts, 1983.

Naef, Weston J. *Counterparts: Form and Emotion in Photographs*. New York: Metropolitan Museum of Art, in association with E. P. Dutton, 1982.

Olander, William. *Picture Taking: Weegee, Walker Evans, Sherrie Levine, Robert Mapplethorpe*. Evanston, Illinois: Mary and Leigh Block Gallery, Northwestern University, 1985.

Parker, Fred. *Attitudes*. Santa Barbara, California: Santa Barbara Museum of Art, 1979.

Photographs from the Collection of Robert Mapplethorpe. New York: Sotheby Parke Bernet Inc., 1982.

Ribalta, J. *Robert Mapplethorpe*. Madrid: Galeria Weber, Alexander y Cobo, 1991.

Robert Mapplethorpe: Early Works. New York: Robert Miller Gallery, 1991.

Robert Mapplethorpe. Tokyo: Tokyo Tien Museum, 1992.

Robert Mapplethorpe. Tokyo: Art Tower Mito and Asahi Shimbun, 1992.

Roche, Denis. *Autoportraits photographiques*. Paris: Centre National d'Art et de Culture Georges Pompidou, 1981.

Saul, Julie M. *Photography in America 1910–1983*. Foreword by Genevieve A. Linnehan. Tampa, Florida: Tampa Museum, 1983.

Schneckenburger, Manfred. *Documenta 6*. Kassel, West Germany: Documenta, 1977.

Sheftel, Bruce. *Presences: The Figure and Manmade Environments*. Reading, Pennsylvania: Freedman Gallery, Albright College, 1980.

Sidlauskas, Susan. *Intimate Architecture: Contemporary Clothing Design*. Cambridge, Massachusetts: Hayden Gallery, List Visual Arts Center, Massachusetts Institute of Technology, 1982.

Smith, Patti. *Robert Mapplethorpe*. Bellport, New York: Bellport Press, 1987.

Squiers, Carol. *Quattro fotografi differenti*. Milan: Padiglione d'Arte Contemporanea and Idea Editions, 1980.

Szarkowski, John. *Mirrors and Windows: American Photography Since 1960*. New York: Museum of Modern Art, 1978.

Wagstaff, Sam. Introduction. *Robert Mapplethorpe Flowers*. Tokyo: Galerie Watari, 1983.

———. Essay. *Robert Mapplethorpe: Process*. New York: Barbara Gladstone Gallery, 1984.

Walsh, Philip Hotchkiss, et al. *Phototypes*. New York: Whitney Museum of American Art, Downtown Branch, 1983.

Weiermair, Peter, ed. *Robert Mapplethorpe*. Introduction by Sam Wagstaff. Frankfurt: Frankfurter Kunstverein, 1981.

White, Edmund. Introduction. *Black Males*. Amsterdam: Galerie Jurka, 1980.

PROJECTS AND BOOKS BY MAPPLETHORPE

still moving/patti smith. Black-and-white film directed by the artist, 1978.

Lady, Lisa Lyon, with text by Bruce Chatwin, foreword by Sam Wagstaff. New York: Viking Press, 1983.

The Agency. New York: Hardison Fine Arts Gallery, 1983.

Lady. Color film directed by the artist, 1984.

Certain People: A Book of Portraits, with text by Susan Sontag. Pasadena, California: Twelvetrees Press, 1985.

Exquisite Creatures, with Gilles Larrain, Deborah Turbeville, and Roy Volkmann; edited by Jim Clyne. New York: William Morrow and Company, 1985.

A Season in Hell, with text by Arthur Rimbaud, translated by Paul Schmidt. New York: Limited Editions Club, 1986.

50 New York Artists, with text by Richard Marshall. San Francisco: Chronicle Press, 1986.

"Portraits in Reflection." Dance project with Lucinda Childs. Joyce Theater, New York, 1986.

Black Book, with foreword by Ntozake Shange. New York: St. Martin's Press, 1986.

Robert Mapplethorpe, with introduction by Ikuroh Takano, interview by David Hershkovits. Tokyo: Parco Co., 1987.

Some Women, with introduction by Joan Didion. Boston: Bulfinch Press; Little, Brown and Company, 1989.

Flowers, with foreword by Patti Smith. Boston: Bulfinch Press; Little, Brown and Company, 1990.

ARTICLES, REVIEWS, AND FILMS

Albright, T. "The World of Decadent Chic." *San Francisco Chronicle* (May 1, 1980).

Aletti, Vince. "Robert Mapplethorpe: 1946–89." *Village Voice* (March 21, 1989).

Aloff, M. "Robert Mapplethorpe." *Dance Research Journal* (Winter 1988).

Anderson, Alexandra. "The Collectors." *Vogue* (March 1985).

Andre, Michael. " 'Recent Religious and Ritual Art' (Buecker and Harpsichords): Robert Mapplethorpe, Lenny Salem, and Royce Dendler." *Art News* (March 1974).

Anfam, David. "Robert Mapplethorpe." *Art International* (Winter 1988).

Aronson, Steven M. L. "Reflections in a Photographer's Eye." *House & Garden* (May 1986).

Artner, Alan G. "'Sex-Specific' Exhibit Is Tiring in Its Unoriginality." *Chicago Tribune* (November 16, 1984).

Auer, James. "Intimate Images." *Milwaukee Journal* (June 16, 1985).

Bahrens, P. "Photos im Zwiespalt." *Rheinische Post* (Germany) (April 16, 1983).

Barrie, D. "Fighting an Indictment: My Life with Robert Mapplethorpe." *Museum News* (July–August 1990).

Bas Roodnat, D. "Mapplethorpe's Foto's Met Onderkoelde 'Power.'" *NRC Handelsblad* (Netherlands) (May 23, 1979).

Berg, André. "Lisa Lyon: Instantanés musclés par Robert Mapplethorpe." *Photo* (France), no. 188.

Berkson, Bill. "Robert Mapplethorpe at Robert Miller." *Art in America* (April 1989).

Boettger, S. "Black and White Leather." *Daily Californian* (April 11, 1980).

Bondi, Inge. "The Yin and Yang of Robert Mapplethorpe." *Print Letter* (Switzerland) (January–February 1979).

Bonney, Claire. "The Nude Photograph: Some Female Perspectives." *Women's Art Journal* (Fall/Winter 1985–1986).

Bonuomo, Michele. "Robert Mapplethorpe, Il diavolo in corpo." *Il Mattino* (Italy) (March 20, 1984).

Bourdon, David. "Robert Mapplethorpe." *Arts Magazine* (April 1977).

Bulgari, Elsa. "Robert Mapplethorpe." *Fire Island Newsmagazine* (July 3, 1978).

Bultman, Janis. "Bad Boy Makes Good." *Darkroom Photography* (July 1988).

Burg, Lester. "Blatantly Subtle." *Gaysweek* (April 23, 1979).

———. "The Art of Being Gay." *Gaysweek* (June 24, 1979).

Burnett, W. C. "Ex-Painter Gets in Focus with Camera." *Atlanta Journal* (April 2, 1982).

Bush, Catherine. "Still Life in Motion." *Theatre Crafts* (February 1987).

Butler, Susan. "Revising Femininity." *Creative Camera* (September 1983).

Catalano, Gary. "Pictures of Sculpture Vision." *The Age* (Australia) (February 12, 1986).

Caujolle, C. "Une photographie très musclée." *Libération* (France) (April 29, 1983).

———. "Robert Mapplethorpe: Black, White and Square." *Beaux Arts Magazine* (France) (November 1983).

———. "Gli inferi fotografici." *Tema Celeste* (Italy) (October 1984).

———. "The Infernal Divinities of Photography in Mapplethorpe and Witkin." *Art Press* (France) (February 1985).

Caujolle, C., Michel Slubicki, and Serge Loupien. "Mapplethorpe, carré noir." *Libération* (France) (March 11, 1989).

Celant, Germano. "Entrevista con Mapplethorpe." *Vardar* (Spain) (May 1984).

———. "Robert Mapplethorpe, 'Man in Polyester Suit.'" *Artforum* (September 1993).

Champeau, Albert. "Robert Mapplethorpe." *Crétis: La photographie au présent* (France), no. 7 (1978).

Chatwin, Bruce. "Body Building Beautiful." *Sunday Times Magazine* (Great Britain) (April 17, 1983).

Chatwin, Bruce, and Donald Richards. "Strong Stuff: Lisa Lyon's Body Beautiful." *Tatler* (Great Britain) (June 1983).

Chua, Lawrence. "Robert Mapplethorpe." *FlashArt* (January–February 1989).

Coleman, A. D. "Robert Mapplethorpe." *Art News* (October 1989).

Coumans, W. K. "Robert Mapplethorpe." *Foto* (August 1979).

Coupland, Ken. "Robert Mapplethorpe." *Sentinel USA* (May 23, 1985).

Daley, Sandy. *Robert Having His Nipple Pierced*. Independent film, 1970.

Danto, Arthur C. "Robert Mapplethorpe." *The Nation* (September 26, 1988).

Davis, Douglas. "The Return of the Nude." *Newsweek* (September 1, 1986).

Didion, Joan. "Some Women." *Esquire* (September 1989).

Derbyshire, Philip. "Not Just a Technical Hitch." *City Limits* (November 4, 1983).

Dills, Keith. *Artweek* (May 18, 1985).

Donkers, Jan. "Fotograaf Robert Mapplethorpe." *A Avenue* (Netherlands) (January 1984).

Dunne, Dominick. "Robert Mapplethorpe's Proud Finale." *Vanity Fair* (February 1989).

Ellenzweig, Allen. "The Homosexual Aesthetic." *American Photographer* (August 1980).

———. "Robert Mapplethorpe at Robert Miller." *Art in America* (November 1981).

Evans, Tom. "Photographer in Focus." *Art and Artists* (Great Britain) (March 1984).

Everly, Bart. "Robert Mapplethorpe." *Splash* (April 1988).

"'Explicit' Photo of Homosexuals Raises Eyebrows." *Daily Telegraph* (Great Britain) (January 1984).

"I famigerati, osceni X, Y, Z." *Il Giornale dell'Arte* (Italy) (November 1991).

Filler, Martin. "Robert Mapplethorpe." *House & Garden* (June 1988).

Finch, Nigel. *Robert Mapplethorpe*. Television documentary. Arena Productions, BBC (Great Britain) (1988).

Fischer, H. "Calculated Opulence: Robert Mapplethorpe." *Artweek* (November 21, 1980).

Flood, Richard. "Skied and Grounded in Queens: New York/New Wave at P.S. 1." *Artforum* (Summer 1981).

Foerstner, Abigail. "Mapplethorpe's Images Combine the Classic and the Erotic." *Chicago Tribune* (February 24, 1989).

Foster, Hal. "Robert Mapplethorpe, Holly Solomon Gallery." *Artforum* (February 1978).

Friedman, Jon R. "Robert Mapplethorpe." *Arts Magazine* (June 1979).

Ginneken, L. van. "Mapplethorpe." *De Volkskrant* (Netherlands) (May 18, 1979).

Goldberg, Vicki. "The Art of Salesmanship: Photography as a Tool of Advertising." *American Photographer* (February 1987).

Green, Janina. "Seductive Style, Chiseled Technique . . . and Too Beautiful." *Melbourne Times* (Australia) (February 12, 1986).

Green, Roger. "Dureau and Mapplethorpe: Two Points of View." *New Orleans Times-Picayune* (January 3, 1982).

————. "Softening a Sexy Image with Flowers." *Lagniappe* (January 3, 1987).

Grundberg, Andy. "Is Mapplethorpe Only Out to Shock?" *New York Times* (March 13, 1983).

————. "Certain People." *New York Times Book Review* (December 8, 1985).

————. "The Mix of Art and Commerce." *New York Times* (September 28, 1986).

————. "Prints That Go Beyond the Border of the Medium." *New York Times* (May 3, 1987).

————. "Portraits in a New Perspective." *New York Times* (June 26, 1988).

Gurstein, Rochelle. "Misjudging Mapplethorpe: The Art Scene and the Obscene." *Tikkun* (November–December 1991).

Haenlein, C. "Robert Mapplethorpe Photo-
graphien 1970–83." *Du: Die Kunst-
zeitschrift* (Germany) (1984).

Hagen, Charles. "Art and Advertising:
Commercial Photography by Artists."
Artforum (November 1986).

———. "Robert Mapplethorpe, Whitney
Museum of American Art." *Artforum*
(November 1988).

Handy, Ellen. "Robert Mapplethorpe/Hollis
Sigler." *Arts Magazine* (December 1983).

Hayes, Robert. "Robert Mapplethorpe."
Interview (March 1983).

Henry, Gerrit. "Outlandish Nature." *Art
News* (April 1977).

———. "Robert Mapplethorpe—
Collecting Quality: An Interview." *Print
Collector's Newsletter* (September–October
1982).

Hershkovits, David. "Shock of the Black
and the Blue." *Soho News* (May 20,
1981).

Himmel, Eric. "Cut Flowers." *Camera Arts*
(April 1983).

Hixson, K. "Robert Mapplethorpe." *Arts
Magazine* (Summer 1989).

Hodges, Parker. "Robert Mapplethorpe
Photographer." *Manhattan Gaze* (Decem-
ber 10, 1979).

Hughes, Robert. "Art, Morals, and Poli-
tics." *New York Review of Books* (April
23, 1992).

Hullenkremer, Marie. "Spitzenpreise für alte
Wolken und aggressive Porträts." *Art*
(Germany) (January 1984).

"In Bloom: Photographs by Robert Mapple-
thorpe." *35mm Photography* (Spring
1979).

Indiana, Gary. "Mapplethorpe." *Village
Voice* (May 14, 1985).

———. "Robert Mapplethorpe." *Bomb*
(Winter 1988).

Januszczak, Waldemar. "A Fistful of Femi-
nine Flattery." *The Guardian* (Great Brit-
ain) (June 27, 1983).

Jentz, T. "Robert Mapplethorpe: Restless
Talent." *New York Photo* (April 1983).

Jodidio, P. "'Une Saison en Enfer,' The
Photographs of Robert Mapplethorpe."
Connaissance des Arts (April 1993).

Johnson, K. "Robert Mapplethorpe." *Art in
America* (December 1991).

Jordan, Jim. "End of the Individual." *Art-
week* (June 1, 1985).

———. "A Decade of Diversity." *Artweek*
(April 11, 1987).

Karcher, Eva. "Gefahrliche Schönheit." *Pan*
(Germany) (Vol. 10, 1988).

Kent, Sarah. "Mapplethorpe." *Time Out* (Great Britain) (November 3, 1983).

Kissel, Howard. "Robert Mapplethorpe: Unsettling Images." *W* (July 14, 1986).

Kisselgoff, Anna. "Dance: Lucinda Childs Offers World Premiere." *New York Times* (January 29, 1986).

Knight, Christopher. "Man of the Year: Robert Mapplethorpe." *The Advocate* (December 18, 1990).

Koch, Stephen. "Guilt, Grace and Robert Mapplethorpe." *Art in America* (November 1986).

Koether, Jutta. "Robert Mapplethorpe, Whitney Museum." *Artscribe International* (Summer 1989).

Koffman, P. "Zwarte Mannen, Gezien door Robert Mapplethorpe." *NRC Handelsblad* (Netherlands) (November 22, 1980).

Kohn, Michael. "Robert Mapplethorpe." *Arts Magazine* (September 1982).

Kolbowski, Silvia. "Covering Mapplethorpe's 'Lady.'" *Art in America* (Summer 1983).

Kramer, Hilton. "Mapplethorpe Show at the Whitney: A Big, Glossy, Offensive Exhibit." *New York Observer* (August 22, 1988).

Kuspit, Donald. "Robert Mapplethorpe: Aestheticizing the Perverse." *Artscribe International* (November–December 1988).

"The Lady Is a Lyon." *American Photographer* (October 1983).

Larson, Kay. "Between a Rock and a Soft Place." *New York* (June 1, 1981).

————. "Robert Mapplethorpe at Robert Miller." *New York* (June 7, 1981).

————. "How Should Artists Be Educated?" *Art News* (November 1983).

————. "Getting Graphic." *New York* (August 15, 1988).

Laude, A. "Creats." *Les Nouvelles Littéraires* (France) (December 15, 1978).

"Der Ledermann Stehr Modell." *Leverkusener* (Germany) (May 6, 1981).

Lee, D. "Robert Mapplethorpe." *Arts Review* (December 9, 1983).

Lemon, Brendan. "Aftershocks." *Aperture* (Spring 1989).

Leonhart, M. Michael. "Photographer Evokes Precise Portrait Statements." *Gay Life* (February 29, 1975).

Levy, Mark. "Robert Mapplethorpe at Fraenkel Gallery." *Images and Issues* (Spring 1982).

Lifson, Ben. "Games Photographers Play." *Village Voice* (April 2, 1979).

———. "Philistine Photographer: Reassessing Mapplethorpe." *The Village Voice* (April 9, 1979).

Lifton, Norma. "Picture-Taking." *New Art Examiner* (February 1986).

Lipson, Karin. "Celebration and Crisis." *Newsday* (August 1, 1988).

Llopis, Silvia. "El sexo es el mensaje." *Cambio 16* (Spain) (May 3, 1984).

Lucie-Smith, Edward. "The Gay Seventies?" *Art and Artists* (December 1979).

———. "Robert Mapplethorpe." *Art and Artists* (November 1983).

Lynch, Kevin. "Mapplethorpe's Art a Sensual Symphony in Black and White." *Milwaukee Journal* (June 30, 1985).

Lynne, Jill. "Interview." *Le Palace Magazine* (France) (October 1981).

Lyon, Christopher. "Sex Hides Below Surface of Contemporary Photos." *Chicago Sun-Times* (November 16, 1984).

Manegold, C. S. "Robert Mapplethorpe, 1970–1983; on the 1983–1984 Retrospective." *Arts Magazine* (February 1984).

———. "Robert Mapplethorpe: The Latest Wave." *Artscribe* (Great Britain) (February–April 1984).

"Mapplethorpe Photographs Seek More than Arousal." *Chicago Tribune* (February 29, 1980).

"Mapplethorpe's Photography Collection Sold." *Maine Antique Digest* (August 1982).

"Mapplethorpe Goes Platinum." *Sentinel USA* (May 23, 1985).

Mapplethorpe, Robert. "Cinq Photographies." *Cahiers de l'Energumène* (France), no. 2 (1983).

———. "Heads and Flowers." *Paris Review* (Spring 1985).

———. "Robert Mapplethorpe." *Parkett 8* (Switzerland) (1986).

———. "Fashion Studies in Black and White." *Interview* (March 1987).

Mapplethorpe, Robert, with Kathy Acker, Joseph Kosuth, and Lawrence Weiner. "Portraits . . ." *Artforum* (May 1982).

Mari, Rafa. "En botica." *Noticias* (Spain) (February 14, 1984).

Marinas, J. Alberto. "Robert Mapplethorpe expone en la Galeria Fernando Vijande." *Diorama, Fotografia, Cine, Sonido, y Video* (Spain) (April 1984).

Marshall, Richard, ed. "Robert Mapplethorpe: Heads and Flowers." *Paris Review* (Spring 1985).

Matthies, Robert. "Lady, Lisa Lyon." Review. *Photographic Society of America Journal* (October 1983).

McDonald, R. "Getting Off (Turning Off?) on Robert Mapplethorpe." *LAICA Journal* (October–November 1978).

McGuigan, Cathleen. "Walk on the Wild Side." *Newsweek* (July 25, 1988).

McKenzie, Barbara. "Robert Mapplethorpe." *Open City* (November 1985).

Miller, Robert L. "From the Publisher." *Time* (April 24, 1989).

Miracco, Franco. "Celebrazione della forma." *Il Mattino* (Italy) (October 18, 1983).

Mittlemark, Howard. "Letter from Japan." *Art and Auction* (November 1984).

Morch, Al. "It's More than Parlor Decadence." *San Francisco Examiner* (November 27, 1985).

Morgan, Stuart. "Something Magic." *Artforum* (May 1987).

———. "Mapplethorpe: Le jeu kaleidoscopique." *Clichés* (Belgium) (October 1987).

Morrisroe, Patricia. "Prints of Darkness." *Sunday Times Magazine* (Great Britain) (October 30, 1983).

Muchnic, Suzanne. "Galleries: La Cienega Area." *Los Angeles Times* (July 9, 1982).

Nicol, G. "Ezfundene Schondert als Schutz." *Tannus* (Germany) (April 14, 1981).

Novi, M. "Tutto il corpo di Lisa." *La Repubblica* (Italy) (April 10, 1983).

Nurnberg, W. "Staging the Self." *British Journal of Photography* (Great Britain) (December 19, 1986).

Paglia, Camille. "The Beautiful Decadence of Robert Mapplethorpe: A Response to Rochelle Gurstein." *Tikkun* (November–December 1991).

Pally, Marcia. "Radiant Rebel." *New York Native* (March 28, 1983).

Panicelli, Ida. "Robert Mapplethorpe, Palazzo delle Centro Finestre, Galleria Lucio Amelio." *Artforum* (October 1984).

Peral, E. "Robert Mapplethorpe: Fotografias, 1970–1983." *Arte Fotografico* (Spain) (May 1984).

Perrone, Jeff. "Robert Mapplethorpe: Robert Miller Gallery." *Artforum* (Summer 1979).

Piguet, P. "Robert Mapplethorpe." *Oeil-Revue d'Art* (January–February 1992).

187

Pinharanda, João. "Robert Mapple-
thorpe—o exercício dos corpos." *Oglobo*
(Portugal) (February 25, 1984).

Pohl, Af Eva. "Drift Over Alle Graenser."
Berlingske Tidende (Germany) (February
8, 1992).

Porter, Allan. "Transfiguration/Configura-
tion: Mapplethorpe." *Camera* (Switzer-
land) (Summer 1977).

Post, Henry. "Mapplethorpe's Camera Lusts
for Exposing Sex Objects." *Gentlemen's
Quarterly* (February 1982).

Pousner, Howard. "Shoot First, Ask Ques-
tions Later." *Atlanta Journal/Atlanta
Constitution* (April 17, 1982).

Pozzo, S. del. "Che forza quell'artista."
Panorama (Italy) (March 14, 1983).

Puglienn, G. "Robert Mapplethorpe." *Zoom*
(France), no. 88.

Quadri, F. "Ossessione nera." *Panorama*
(Italy) (June 15, 1981).

Raynor, Vivien. "Split Vision." *New York
Times* (January 10, 1986).

Revenga, Luis. "Las flores negras de Mapple-
thorpe, y otros." *El Paìs* (Spain) (April
27, 1985).

Ricard, Rene. "Patti Smith and Robert
Mapplethorpe at Miller." *Art in America*
(September–October 1978).

Rimanelli, David. "Robert Mapplethorpe,
Robert Miller Gallery." *Artforum* (Octo-
ber 1991).

Rip, Allan. "Mapplethorpe." *American Pho-
tographer* (January 1988).

"Robert Mapplethorpe: Le portrait 'in-
time.'" *Photo* (France) (February 1978).

"Robert Mapplethorpe." *San Francisco Bay
Guardian* (April 30, 1980).

"Robert Mapplethorpe." *The Advocate* (July
24, 1980).

"Robert Mapplethorpe." *Le Palace Magazine*
(France) (December 1981).

"Robert Mapplethorpe faire de l'art avec des
tabous." *Photo-Reporter* (France) (Janu-
ary 1983).

"Robert Mapplethorpe." *East Village Eye*
(April 1983).

"Robert Mapplethorpe." *British Journal of
Photography* (Great Britain) (November
25, 1983).

"Robert Mapplethorpe." *Photo Japon* (Japan)
(January 1984).

"Robert Mapplethorpe." *Photo Japon* (Japan)
(September 1986).

Robinson, Gil. "Photographer Robert Map-
plethorpe Comes to Atlanta." *Gazette
Newsmagazine* (April 8, 1982).

Roegiers, Patrick. "Mort du photographe Robert Mapplethorpe: Un classique moderne." *Le Monde* (France) (March 11, 1989).

Rooney, Robert. "The Unambiguous Stare of Mapplethorpe's Lens." *The Australian* (Australia) (February 25, 1986).

Rozon, R. "The Challenges of the Salon National of the Montreal Art Galleries." *Vie des Arts* (Canada) (March 1985).

Ruehlmann, William. "It May Be Kinky but He Says It's Art." (Norfolk) *Ledger-Star* (January 25, 1978).

Salatino, Kevin. "Robert Mapplethorpe." *New Art Examiner* (May 1989).

Schjeldahl, Peter. "The Mainstreaming of Mapplethorpe, Taste and Hunger." *7 Days* (August 10, 1988).

Schwabe, G. "Fotograften." *Kunstwerk* (Germany) (May 1987).

Scobie, W. I. "Mad for Each Other." *The Advocate* (June 9, 1983).

Sekula, Allan. "Some American Notes." *Art in America* (February 1990).

"Du sens et du sensuel." *Il Connaissance des Arts* (France) (March 1985).

Sidlauskas, Susan. "Ambulant Architecture: The Body as Blueprint." *Alive* (September–October 1982).

Simson, Emily. "Portraits of a Lady." *Art News* (November 1983).

Sischy, Ingrid. "Lisa Lyon." *Artforum* (November 1980).

———. "White and Black." *New Yorker* (November 13, 1989).

Sontag, Susan. "Sontag on Mapplethorpe." *Vanity Fair* (July 1985).

Squiers, Carol. "With Robert Mapplethorpe." *The Hamptons Newsletter* (August 27, 1981).

———. "The Visible Face." *Village Voice* (November 30, 1982).

———. "Undressing the Issues." *Village Voice* (April 5, 1983).

———. "Mapplethorpe Off the Wall." *Vanity Fair* (January 1985).

Squiers, Carol, Allan Ripp, and Stephen Koch. "Mapplethorpe." *American Photographer* (January 1988).

Stretch, Bonnie Barrett. "Contemporary Photography." *Art and Auction* (May 1987).

Sturman, John. "Robert Mapplethorpe." *Art News* (November 1985).

"Symboles de Mapplethorpe—fantasmes sur le theme de 'L'homme, Jardin de Géométrie.'" *Photo* (France) (October 1981).

Szegedy-Maszak, Andrew. "A Distinctive Vision: The Classical Photography of Robert Mapplethorpe." *Archaeology* (January–February 1991).

Tamblyn, Christine. "Poses and Positions." *Artweek* (June 27, 1987).

Tannenbaum, J. "Robert Mapplethorpe— The Philadelphia Story." *Art Journal* (Winter 1991).

Tatransky, Valentin. "Robert Mapplethorpe." *Arts Magazine* (April 1977).

Temin, Christine. "Robert Mapplethorpe's Poetic and Seductive 'Perfect Moment.'" *Boston Globe* (July 3, 1990).

Teraoka, M. "Portrait of Robert Mapplethorpe." *Artforum* (November 1990).

Thompson, Mark. "Mapplethorpe." *The Advocate* (July 24, 1980).

Thorn-Prikker, Von Jan. "Robert Mapplethorpe: Soul on Ice." *Wolkenkratzer Art Journal* (Germany) (May–June 1989).

Thornton, Gene. "This Show Is a Walk Down Memory Lane." *New York Times* (September 28, 1983).

Tilendis, Robert M. "Robert Mapplethorpe 1946–1989." *New Art Examiner* (May 1989).

Tobias, Tobi. "Mixed Blessings." *New York* (February 17, 1986).

Tourigny, Maurice. "Robert Mapplethorpe: Oeuvres de jeunesse." *Vie des Arts* (France) (September 1991).

Trucco, Terry. "State of the Art: Print Sales in Cameraland." *American Photographer* (January 1984).

Vormese, Francine. "Lisa Lyon, une force de la nature." *Elle* (France) (May 2, 1983).

Walker, Anne. "Holly Solomon/Robert Mapplethorpe." *Shift*, no. 1 (1987).

Weaver, Mike. "Mapplethorpe's Human Geometry: A Whole Other Realm." *Aperture* (Winter 1985).

Weiley, Susan. "Prince of Darkness, Angel of Light." *Art News* (December 1988).

Welch, Marguerite. "Mapplethorpe's Garden: Manhattan 'Fleurs du Mal.'" *New Art Examiner* (January 1982).

Whelan, Richard. "Robert Mapplethorpe: Hard Sell, Slick Image." *Christopher Street* (June 1979).

White, Edmund. "The Irresponsible Art of Robert Mapplethorpe." *The Sentinel* (September 5, 1980).

Wiegand, Wilfried. "Gnadenlose Schön-
heit." *Frankfurter Allgemeine Zeitung*
(Germany) (March 11, 1989).

Wilkinson, Sean. "Mapplethorpe, Money,
and the Generative Member." *Images Ink*
(Vol. 5, No. 1/2).

Zaya. "Los 'Negros Viriles' de Robert Map-
plethorpe." *Los Cuadernos del Norte*
(Spain) (January–February 1983).

Zelavansky, Lynn. "Robert Mapplethorpe:
Leo Castelli." *FlashArt* (Summer 1983).

Zellweger, Harry. "Ausstellungs-Ruckschau:
London." *Das Kunstwerk* (Germany)
(February 1984).

Ziegler, U. "Contemporary Art Must Re-
legitimize Itself—On the Dispute over
Robert Mapplethorpe." *Merkur: Deutsche
Zeitschrift für Europäisches Denken*
(October–November 1990).

Kastor, Elizabeth. "Funding Art That Of-
fends: NEA Under Fire Over Controver-
sial Photo." *Washington Post* (June 7,
1989).

———. "Corcoran Decision Provokes
Outcry." *Washington Post* (June 14,
1989).

Gamarekian, Barbara. "Washington Gallery
Cancels Mapplethorpe Show." *New York
Times* (June 15, 1989).

Honan, William H. "Congressional Anger
Threatens Arts Endowment's Budget."
New York Times (June 20, 1989).

Kramer, Hilton. "Is Art Above the Laws of
Decency?" *New York Times* (July 2,
1989).

Danto, Arthur C. "Art and Taxpayers." *The
Nation* (August 21, 1989).

De Vries, Hilary. "The Politics of Art."
Boston Globe Magazine (December 24,
1989).

Kastor, Elizabeth. "Soul-Searching at the
Corcoran." *Washington Post* (December
24, 1989).

Artner, Alan G. "The 1989 Artist of the
Year: Photographer Robert Mapple-

thorpe." *Chicago Tribune* (December 31, 1989).

Fleeson, Lucinda. "Cincinnati vs. Mapplethorpe." *Philadelphia Inquirer* (April 6, 1990).

Wilkerson, Isabel. "Nervous Cincinnatians Brace for Exhibit Today." *New York Times* (April 7, 1990).

Dennis, Debra. "The Whole World Is Watching." *Cincinnati Post* (April 9, 1990).

Dennis, Debra, and Steve Burke. "Jury Will Decide Criminal Charges, If Photos Obscene." *Cincinnati Post* (April 9, 1990).

Kay, Joe. "Thousands See Exhibit: Many Angry at Bid to Censor It." Associated Press (April 9, 1990).

Richard, Paul. "The Debate on the Disgusting: Mapplethorpe's Defenders, Forced to Fight on Low Ground." *Washington Post* (April 15, 1990).

Anderson, Harry, and Shawn D. Lewis. "The Battle of Cincinnati: A Sexually Explicit Exhibition Divides the City." *Newsweek* (April 16, 1990).

Barclay, Delores. "The Naked Storm: Mapplethorpe as Martyr." Associated Press (April 17, 1990).

"Obscene in the Midwest." *The Economist* (April 20, 1990).

Gwynne, S. C. "Eruptions in the Heartland: Battling Bluenoses." *Time* (April 23, 1990).

Mansnerus, Laura. "The Cincinnati Case: What Are the Issues and the Stakes?" *New York Times* (April 24, 1990).

Wilkerson, Isabel. "Legal Fight Goes on as Disputed Exhibit Ends." *New York Times* (May 26, 1990).

Carr, C. "War on Art: The Sexual Politics of Censorship." *Village Voice* (June 5, 1990).

Parachini, Allan. "Judge Won't Drop Charges Against Museum." *Los Angeles Times* (June 20, 1990).

Findsen, Owen. "Ruling That CAC Is Not a Museum Jolts Art World: Obscenity Case Takes New Turn as Judge Challenges Center's Status." *Cincinnati Enquirer* (June 21, 1990).

Mathews, Tom, Gregory Cerio, Tony Clifton, and Daniel Glick. "Fine Art or Foul?" *Newsweek* (July 2, 1990).

Carr, C. "The New Outlaw Art." *Village Voice* (July 17, 1990).

Rizzo, Frank. "Mapplethorpe Exhibit Comes to Boston: Despite Opposition, Show Will Go on." *Hartford Courant* (July 23, 1990).

Butterfield, Fox. "In Mapplethorpe Flap, an Echo of a City's Past." *New York Times* (July 31, 1990).

Hartigan, Patti. "Mapplethorpe Show to Open Amid Controversy." *Boston Globe* (August 1, 1990).

French, Desiree, and Vernon Silver. "Shouting Breaks the Calm at ICA." *Boston Globe* (August 2, 1990).

Rezendes, Michael. "Spoiling for Fight, O'Neill Finds the Perfect Moment." *Boston Globe* (August 2, 1990).

Rezendes, Michael, and Patti Hartigan. "Bid to Pull ICA Photos Is Stymied." *Boston Globe* (August 9, 1990).

Selcraig, Bruce. "Reverend Wildmon's War on the Arts." *New York Times Magazine* (September 2, 1990).

Hartigan, Patti. "Latest Mapplethorpe Flare-up Fizzles Out." *Boston Globe* (September 6, 1990).

Masters, Kim. "Gallery Must Face Obscenity Trial: Ruling Blow to Defense in Mapplethorpe Case." *Washington Post* (September 7, 1990).

"Obscenity Jurors to View Five Photos: Judge Rejects Museum's Bid for Consideration of Entire Mapplethorpe Show." *New York Times* (September 7, 1990).

Masters, Kim. "Jury Pool Gets the Picture: Defense Describes Mapplethorpe Photos." *Washington Post* (September 26, 1990).

Salisbury, Stephan. "Graphic Questions: Potential Jurors Are Asked in Detail about Their Beliefs." *Philadelphia Inquirer* (September 26, 1990).

Wilkerson, Isabel. "Jury Selected in Ohio Obscenity Trial." *New York Times* (September 28, 1990).

———. "Museum Obscenity Trial Opens." *New York Times* (September 29, 1990).

"Curator Says She Knew Mapplethorpe Photos Might Offend." United Press International (October 2, 1990).

Salisbury, Stephan. "Obscenity Trial Jurors See Photos by Mapplethorpe." *Knight-Ridder Newspapers* (October 3, 1990).

Dennis, Debra. "Barrie Defends Show, Artistic Principles." *Cincinnati Post* (October 4, 1990).

"Mapplethorpe 'Brilliant,' Gallery Director Testifies." Associated Press (October 4, 1990).

Masters, Kim. "Disputed Expert Says Photos Aren't Art: Mapplethorpe Pictures Don't Express Emotion, 'Sexualize' Children, Witness Testifies." *Washington Post* (October 5, 1990).

"Witness: Mapplethorpe Photos 'Destructive.'" *New York Times* (October 5, 1990).

Harrison, Eric, and Allan Parachini. "Mapplethorpe Photos Not Obscene." *Los Angeles Times* (October 6, 1990).

"Jurors Acquit Museum Despite Dislike of Sexually Explicit Photos." *The Sun* (Baltimore) (October 7, 1990).

"Mapplethorpe Jurors Speak Out." Associated Press (October 8, 1990).

Lewis, Jo An. "Corcoran in Red After Show Controversy: Financial Trouble Laid to Mapplethorpe Cancellation." *Washington Post* (October 26, 1990).

Cembalest, Robin. "The Obscenity Trial: How They Voted to Acquit." *Art News* (December 1990).

Designer: Sandy Drooker
Compositor: Braun-Brumfield, Inc.
Text: 13/20 Fournier
Display: Fournier
Printer: Llovet International
Binder: Llovet International